IMAGES
of America

ASHLAND

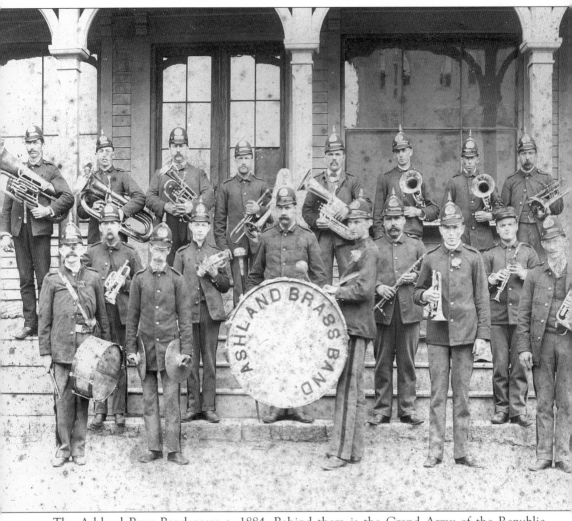

The Ashland Brass Band poses *c.* 1884. Behind them is the Grand Army of the Republic building at the corner of Main and Summer Streets, where the post office stands today.

On the cover: Employees of the Warren Telechron Company gathered for an outing at Riverside on the Charles on September 22, 1928.

IMAGES
of America

ASHLAND

Edward A. Maguire and R. Marc Kantrowitz

ARCADIA

First printed in 2001.

Published by Arcadia Publishing,
an imprint of Tempus Publishing, Inc.
2A Cumberland Street
Charleston, SC 29401

Printed in Great Britain.

Library of Congress Catalog Card Number: 2001089088

For all general information contact Arcadia Publishing at:
Telephone 843-853-2070
Fax 843-853-0044
E-Mail sales@arcadiapublishing.com

For customer service and orders:
Toll-Free 1-888-313-2665

Visit us on the internet at http://www.arcadiapublishing.com

*Dedicated to the memory of those who have played roles,
major and minor, in Ashland's history and especially to those who
had the foresight to preserve that history for future generations.*

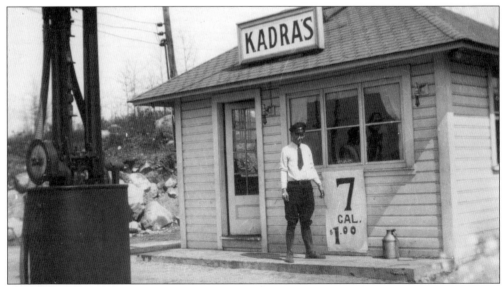

Kadra's service station was on Waverly Street (Route 135) near the Ashland-Framingham town line. The photograph was taken in June 1931. The station burned in November 1933.

CONTENTS

ACKNOWLEDGMENTS

The authors would like to acknowledge the Ashland Historical Society for its encouragement of the project. In particular, the assistance of Catherine G. Powers, curator, and Richard J. Fannon is very much appreciated. Most of the images come from the files at the society. Some were made available from private collections and are noted as such in the captions accompanying those images. Our thanks go to Robert Hebden, Thomas G. Waldstein, Mary B. Walkup, and Clifford Wilson in this regard.

Every effort has been made to identify the pictures adequately and accurately. We apologize if there are any errors and welcome corrections.

This volume has been compiled to present an overview of Ashland's history. For more information about the town, please reference the volumes listed below.

BIBLIOGRAPHY

Ashland, Massachusetts 150th Anniversary Commemorative Book 1846–1996. Ashland, Massachusetts: Design West, 1996.

Conklin, Edwin P. *Middlesex County and Its People*, Volume II. New York: Lewis Historical Publishing Company, 1927.

Drake, Samuel Adams. *History of Middlesex County, Massachusetts*, Volume I. Boston, Massachusetts: Estes and Lauriat, 1880.

Hurd, D. Hamilton. *History of Middlesex County, Massachusetts*, Volume III. Philadelphia, Pennsylvania: J.W. Lewis & Company, 1890.

Works Projects Administration. *History of the Town of Ashland.* Framingham, Massachusetts: Lakeview Press, 1942.

INTRODUCTION

Ashland, Massachusetts, is 24 miles west of Boston. It is situated in a small valley at the confluence of the Sudbury River and Cold Spring Brook. A receding glacier left low rolling hills north, south, and west of the central plain. Remnants of a prehistoric lake are found in the southeastern portion.

Native Americans surely knew the area, as one of their principal trails passed through it. This connected Massachusetts Bay with the Connecticut River Valley. Early colonists made use of the trail, which came to be known as the Old Connecticut Path. The Native Americans left no evidence of any permanent settlement until John Eliot established one of his "Praying Indian" towns on Magunko Hill in the western part of the valley.

The Honorable William Crowne was granted a 500-acre tract in the area destined to become the town of Ashland. Crowne never occupied the grant, which abutted Danforth's Farms, as the future Framingham was known. He sold his lands to Savil Simpson of Boston, who added to his holdings with subsequent purchases. Simpson and his family became the first permanent settlers of Ashland.

The soil was not especially well suited to agriculture. However, land was cleared, houses were built, and small farms developed. Apparently, forage crops were the mainstays and dairy cows were raised. Apple orchards did well in the uplands.

It was the streams that were the most attractive feature of the area. The Sudbury River was not very large as rivers go, and Cold Spring Brook was even smaller. Nevertheless, both offered the potential for waterpower as they flowed quietly to the east. Numerous small dams were built with accompanying gristmills, sawmills, forges, and so on. As time passed, larger mills and factories came.

The community developed around the valley's central plain. Outlying farms and mills were joined to this developing center by rough roadways and small bridges. A county road traversed the valley, largely following the Old Connecticut Path. Gradually, the community came to be known as Unionville, as it occupied portions of three adjacent towns: Hopkinton, Framingham, and Holliston. Development received an enormous boost when the railroad came to town. In 1834, the first trains arrived on the newly laid tracks of the Boston to Worcester line.

A desire for its own identity grew within the community, resulting in petitions to the state legislature for the formation of a new town. The request was granted and, in 1846, Ashland came into being. The new government set to work establishing schools, roads, a fire department, a town hall, and necessary town offices. The town flourished as boot and shoe factories, cotton and paper mills, and other businesses grew. There is no doubt that, besides providing its share of men to serve the Union during the Civil War, the town's businesses received a share of the federal government's orders for material. Many new homes were built in the time during and after the war.

One of the first concerns when the town was incorporated was the establishment of a school system. District schools were set up, attended by pupils of all grades living within each district. This arrangement was necessary because of the limited transportation available at that time.

Some consolidation occurred when a town hall was built in 1855 with provisions for classrooms. The district schools were phased out entirely when South School was built on South Main Street. A high school was constructed on Central Street. As the town grew during the 20th century, new schools were erected, including today's Pittaway School on Central Street, the Warren School on Fruit Street, the Mindess Middle School on Concord Street, and the Ashland High School on West Union Street.

Sports have always been a favorite entertainment for the people of Ashland. In the late 19th and early 20th centuries, there were town baseball teams to follow. Baseball continues to be played by a vigorous youth program, a high school team and, for many years, an American Legion–sponsored team. High school teams in many sports have been supported and enjoyed. A highlight every year is the traditional Thanksgiving Day football game against Hopkinton. Teams have been competitive in other sports such as track and field, cross-country, field hockey, basketball, and wrestling. An annual event of international fame had its beginnings in Ashland. For 27 years, the starting line for the Boston Marathon was in Ashland. It was initially on Pleasant Street. It was then moved to the bridge on High Street and moved again to West Union Street. The last start in Ashland was in 1923.

The religious needs of Ashland's residents have been met by many groups over the years. It began with a Sabbath school in 1828, which eventually became the Congregational church on Main Street. A Baptist group built a church on Summer Street, and a Methodist group built one on Alden Street. These three churches merged into the Federated Church. Catholics held services in the Ashland Town Hall starting c. 1855 and built a church on Esty Street in 1874. A Jewish organization conducted a camp off Cedar Street, which for many years attracted thousands of people to its events. Today, there is an Indian temple, a Jehovah Witnesses Kingdom Hall, a Christian Fellowship church, and a fledgling Jewish temple.

A severe blow to the local economy came in 1872. The Boston Water Board claimed rights to the Sudbury River and its tributary streams for development of a reservoir system. Factories along the river were closed. Businesses declined and buildings were unoccupied for years. Shortly after 1900, some small manufacturing firms moved into town. The Lombard Governor Company was one of the first. The Angier Mills, the Fenwal Corporation, and others followed. With Lombard Governor came Henry E. Warren, destined to revitalize the town in many ways. His inventions led to the formation of the Warren Clock Company. This became Warren Telechron and, eventually, Telechron with General Electric's ownership.

With this revival came new development within the town. A public library was erected. A system of waterworks was built. There was a new school on Central Street, and the high school was renovated. The fire department moved into new quarters on Main Street. A post office went up at Main and Summer Streets. Local businesses grew and adapted for the war effort in the 1940s.

Ashland's men and women have served their country in times of war. More than 160 men enlisted in the Union forces during the Civil War. When the fighting was over, a strong Grand Army of the Republic (GAR) thrived in Ashland for many years. The Spanish-American War, World War I, World War II, and the Korean and Vietnam Wars saw local men and women in uniform. Veterans' organizations, such as the American Legion and Veterans of Foreign Wars (VFW), have had posts in Ashland up to the present day.

Ashland's growth continued after World War II. The community was changing from a manufacturing town to a more residential one. Greater mobility, particularly due to the automobile, enabled people to live in towns somewhat removed from their workplaces. Ashland was a desirable small town. Population increased. New schools and a police station were added during this time. Construction of a sewer system began. Some existing town facilities such as the Ashland Town Hall were renovated. Growth has continued into the 21st century.

The future builds upon today and today upon yesterday. Knowledge and understanding of our history helps us build more constructively. It is hoped that this small book with its images of the past will contribute to this background on the local-history level and foster an appreciation of the enterprising and energetic people who have been and continue to be Ashland.

One
EARLY SETTLEMENT

People were drawn to the area destined to become Ashland because of the streams that flowed through the area. First the Native Americans and then the colonists found their way here. One of the earliest permanent structures was this gristmill built in 1735 beside a dammed portion of the Sudbury River, where present-day Myrtle Street crosses the stream.

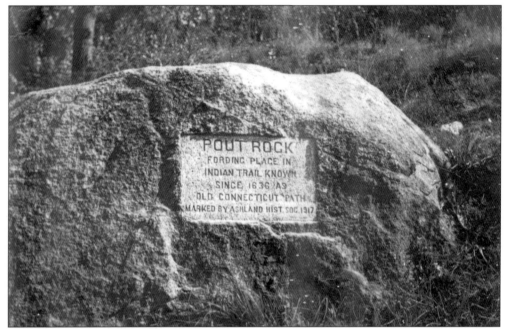

Native Americans traveled by foot through the area we know today as Ashland. The principal trail became known as the Connecticut Path. Cold Spring Brook was forded by the path at Pout Rock. The site off South Main Street is marked by an inscription in this boulder.

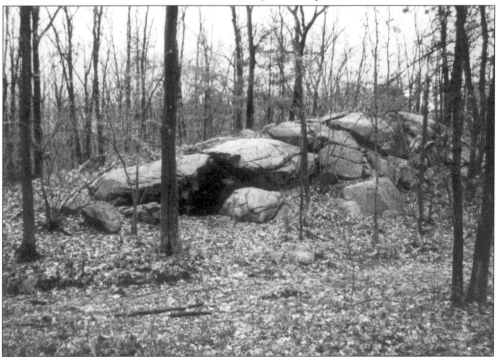

Another spot along the Connecticut Path is known as Devil's Den. Just east of today's Wildwood Cemetery, this cave was said to be a resting point and place for storage of corn and provisions. The old Mendon Road from Framingham crossed the Connecticut Path at this place.

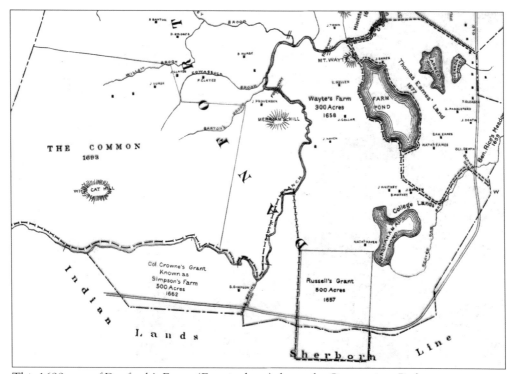

This 1699 map of Danforth's Farms (Framingham) shows the Connecticut Path route traversing from Waushakum, across Ashland, and into the region that was to become Hopkinton. The original land grants belonged to Colonel Crowne. Savil Simpson of Boston purchased 500 acres and became the first settler in Ashland.

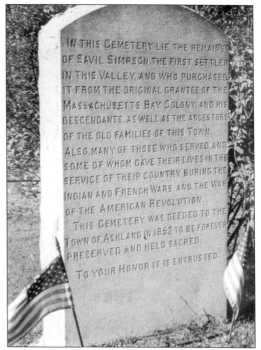

Savil Simpson's homestead was in the vicinity of today's Main and Union Streets. The family burial plot was on the north side of the road and contains the graves of many early settlers. It is variously known as the Revolutionary War Cemetery, South Island, or South Ireland Cemetery. Only a handful of grave markers remains.

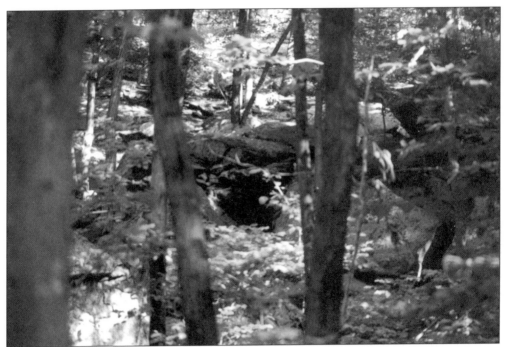

In the Ashland Town Forest, near the Salem End section of Framingham, there is a feature possibly used for shelter by the natives. It is a shallow cave known as the Witches' Cave. Families seeking refuge from the witch trials in Salem are reported to have taken shelter there their first winter before building permanent homes in the area.

In the early 1700s, many farms were established. Yesteryear Farm on High Street is typical. Built c. 1740 by Josiah Burnham, it was home to four generations of the Burnham family. In 1899, ownership passed to the A.C. Whittemore family.

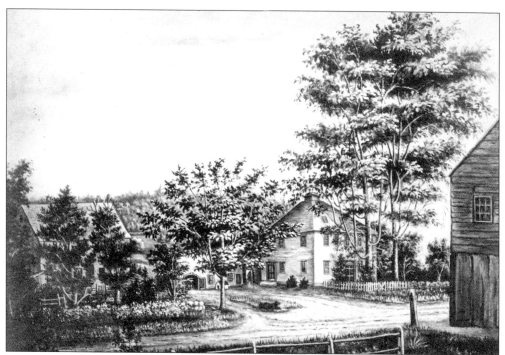

This pen-and-ink sketch shows the Thomas Valentine homestead in 1730. The property is located on present-day West Union Street, east of Frankland Road. The Valentines played a prominent role in Ashland's early development.

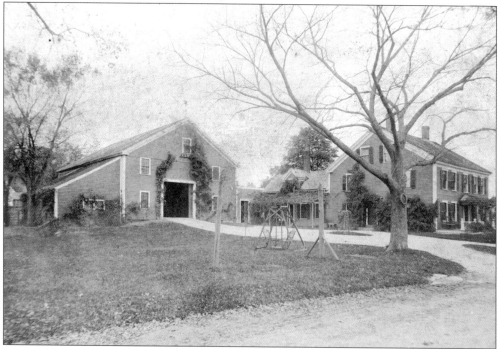

It is said that at some point in time the Valentine place was destroyed by fire and was rebuilt. This *c.* 1920 image shows definite differences in comparison with the earlier sketch.

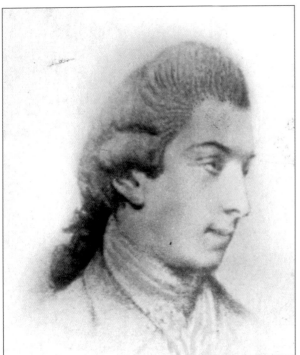

Sir Charles Henry Frankland (1716–1768) was appointed collector of the Port of Boston in 1741. He bought 480 acres in the eastern portion of Hopkinton in 1749 and built a substantial manor there. He died in England in 1768 at 52 years of age.

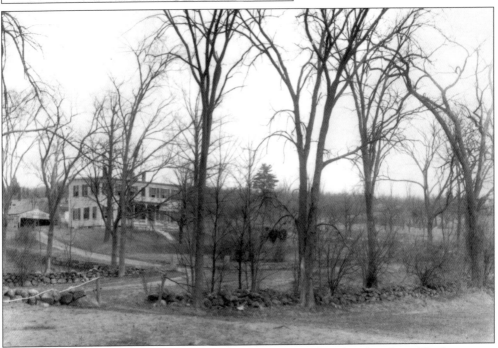

Frankland Farm was along the Connecticut Path, west of the Valentine place. The house was large, with numerous barns and outbuildings. There were terraces, gardens, and orchards. Sir Harry and Lady Frankland entertained there in lavish style. The original house burned in 1858, was rebuilt, and burned again. This photograph was taken in the late 1800s. (Courtesy of Mary B. Walkup.)

In 1742, Agnes Surriage was a 16-year-old daughter of a Marblehead fisherman when Sir Harry took her in. Their liaison was a scandal of the time and the move from Boston to Hopkinton was made to avoid the social pressures. Agnes and Sir Harry eventually married in 1755. Given safe passage through the Colonial siege lines in 1775, Agnes moved to Boston and then to England, never to return.

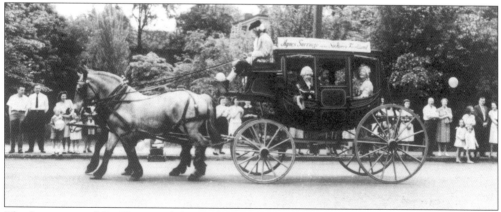

The love story of Sir Harry and Agnes Surriage is still remembered and retold. This carriage appeared in a parade celebrating Ashland's centennial in 1946.

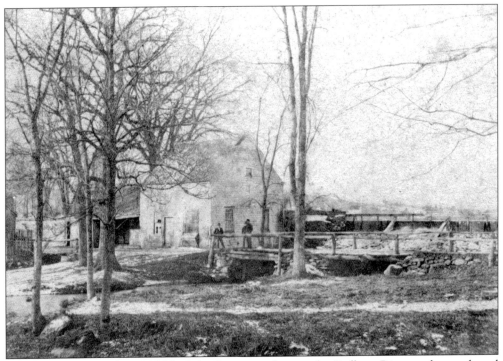

This gristmill was built in 1735 by John Jones at a dam on the Sudbury River at the north end of Main Street. When the building was torn down in 1908, the interior was still in usable condition. It probably would have stood many more years. A sawmill and fulling mill on the site had been removed in prior years.

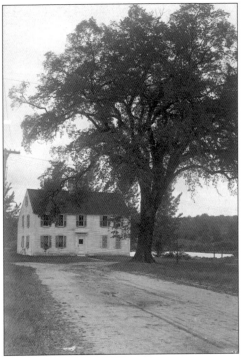

The father of Col. John Jones Jr. built this home for his son at the north end of Main Street in 1748. The younger Jones operated the gristmill adjacent to the house. Called the Ocean House, it is today home to the Ashland Historical Society. Whence the name Ocean House? No one knows for sure, but most believe the proximity of the millpond had its influence.

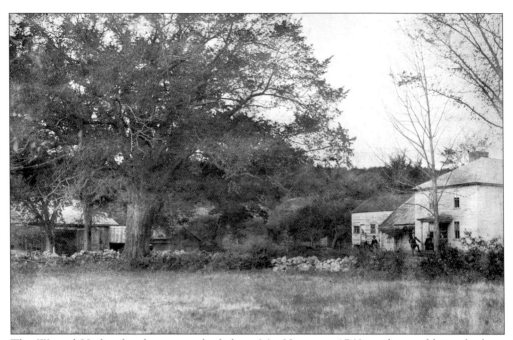

The Wenzel-Higley farmhouse was built by a Mr. Haven *c.* 1760, with an addition built in 1814. The Wenzels and their descendants occupied it from 1801 to 1905, when it was sold to the Dodds. It was situated on Cedar Street. This photograph was taken in 1895.

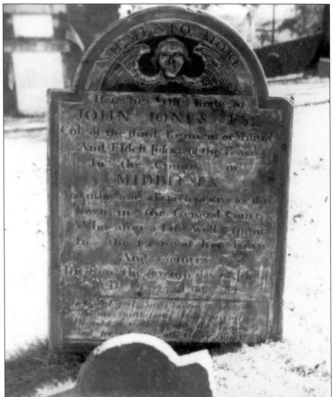

John Jones settled in Ashland in 1710. He was commissioned justice of the peace by King George II and, in 1743, received a commission as colonel of the 3rd Massachusetts Regiment of Militia from Governor Shirley. He served at Crown Point and Ticonderoga and was a member of a committee of safety prior to the Revolution. He died in 1773, recognized as a veteran for his service. His two sons and a grandson also served in the Revolutionary War.

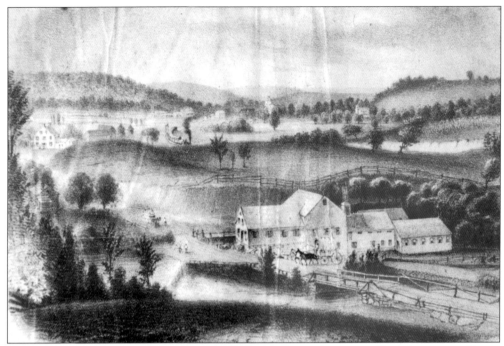

This early view of Unionville (later Ashland) shows Shepard's paper mill on the river at Union and Fountain Streets. The mill, built in 1828, was operated by Calvin Shepard and his son. It burned in 1842, was rebuilt, and then closed in 1856. Newsprint was produced by hand at first and, later, using waterpower. The village can be seen in the distance.

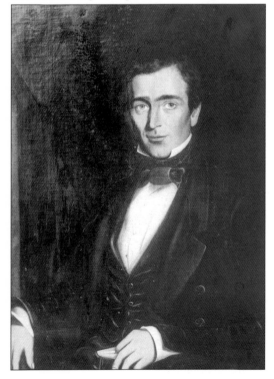

Calvin Shepard Jr. (1806–1890) owned the paper mill. In 1835, he was elected first deacon of the First Parish (later the Congregational Church). He was first chairman of selectmen and first senator from Ashland in the state legislature.

Two

INCORPORATION AND 19TH-CENTURY DEVELOPMENT

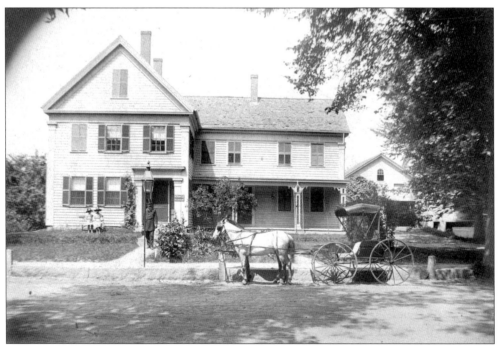

Dr. Richard Russell leaves his office on Summer Street to make house calls. The house was built by one of the Valentine family at the corner of Park and Summer Streets.

𝔐𝔦𝔡𝔡𝔩𝔢𝔰𝔢𝔵, ss. To WILLIAM SEAVER, an inhabitant of the town of Ashland in the County of Middlesex, Greeting.

IN THE NAME OF THE COMMONWEALTH OF MASSACHUSETTS, you are directed to notify the inhabitants of the town of Ashland, qualified to vote in elections and in town affairs, to meet at the Hall called the Chapel, in said Ashland, on MONDAY, *the 30th day of March instant*, at one o'clock in the afternoon, then and there to act on the following articles :—

1. To choose a Moderator to preside in said meeting.

2. To choose all necessary Town Officers for the year ensuing.

3. To see how the town will have their future meetings warned and act thereon.

And you are directed to serve this warrant by leaving a written or printed copy thereof, in each family in said town, at least eight days before the time for holding said meeting.

Hereof fail not, and make due return of this warrant, with your doings thereon, to any Justice of the Peace for the County of Middlesex, at the time and place of said meeting.

Given under my hand at Ashland, this eighteenth day of March, in the year one thousand eight hundred and forty-six.

CALVIN SHEPARD, *Justice of the Peace.*

Unionville was incorporated as the town of Ashland in 1846. This is the warrant issued by Maj. Calvin Shepard, justice of the peace, announcing the first town meeting. It was held in Chapel Hall on the present site of the Ashland Town Hall.

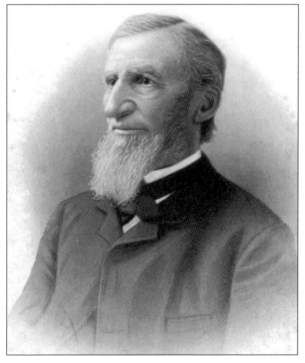

This is an engraving of Elias Grout Jr., who was a successful teacher for many years. Born in 1816, he was the sixth generation of Grouts in the colonies since 1638. In 1853, he was sent as representative to the state legislature. He served the town in many capacities, including selectman, assessor, and school committee member.

Andrew Allard was a prominent landowner at the time. He was one of the town's first selectmen and served on the Ashland Town Hall Building Committee in 1855.

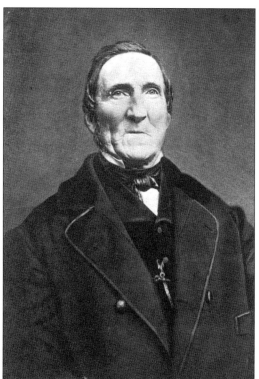

Deacon Dexter Rockwood was another member of Ashland's first board of selectmen. His home was located in the area of town taken in later years for the construction of Hopkinton Reservoir.

Deacon Charles F.W. Parkhurst was Ashland's first town clerk. His was one of the early families to settle in the area.

Michael Homer (1779–1845) was born at the Homer homestead on the corner of Union Street and Homer Avenue, where a service station is located today. He married a member of the Benjamin Haven family of Framingham.

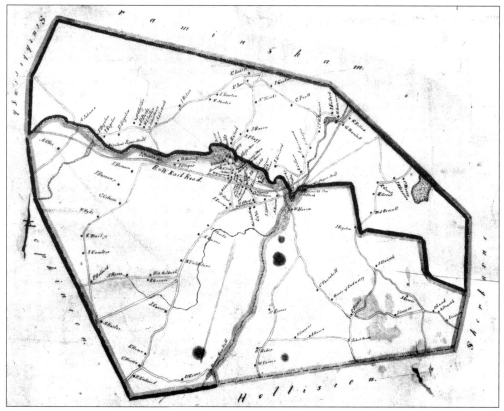

Ashland was formed of parts of Framingham, Hopkinton, and Holliston. The area had become known as Unionville. This 1836 map shows the boundaries proposed for the new town. The roads and buildings existing at the time are shown also.

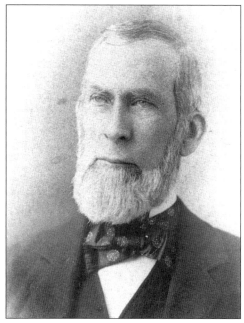

William F. Ellis did virtually all the survey work locally. He served as town clerk from 1849 to 1855 and was known for his bold, uniform handwriting. He was a selectman in 1848, 1866, 1869, and 1887. He served as a state representative in 1859 and 1877 and held numerous other town offices.

This house was built by Matthew Metcalf in 1792 at the intersection of Pleasant and High Streets. It was the home for many years of Josiah Cloyes and his family. Known as Maguncoag Farm, it consisted of several hundred acres. In 1939, it was bought by the Giargiari family. Today, it is Burnam's Supper House restaurant.

Arthur Cloyes was the son of Josiah Cloyes. The Cloyes family was one of those coming to Framingham's Oregon District seeking refuge from the witchcraft trials in Salem. Arthur was born at Magungoag Farm. He served as town clerk from 1857 to 1861.

James Edward Tilton was a member of a prominent Ashland family. He served as town clerk from 1862 to 1864.

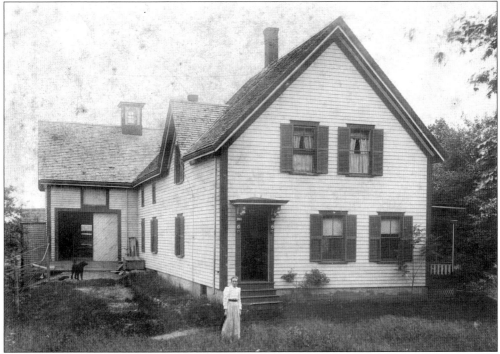

This house was built by Charles S. Norton. The Pratt family moved here in 1887 and occupied the Concord Street home for many years.

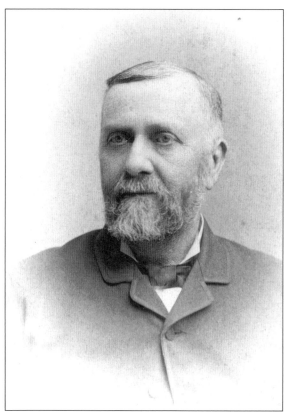

John Clark (1825–1904) came to Ashland in 1850 and began manufacturing tinware. He built a shop on Front Street that was used for many years as a hardware store. Eventually, he sold to Edwin Perry and Franklin Enslin. Clark served as state legislator in 1865 and was a selectman in 1858, 1870, 1871, and 1872. He owned many pieces of property in town.

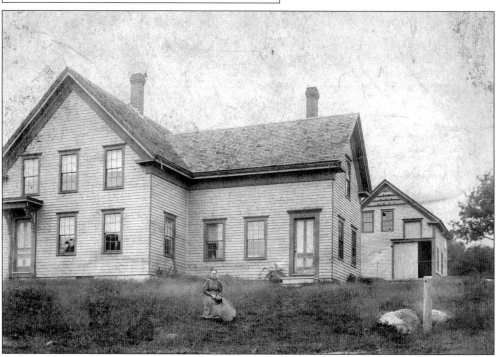

The James Brewer house, built c. 1890, was located on Cordaville Road.

William Eames was a selectman for 10 terms between 1847 and 1859. He held various posts in town, but the most unusual one was serving on a committee to build a town hearse house and purchase a hearse to put in it.

The Captain Eames House was on Fruit Street across from today's Warren School. It served as Holliston's Poor Farm in the early to mid-19th century. Maintenance of the farm was a concern at the time of Ashland's incorporation.

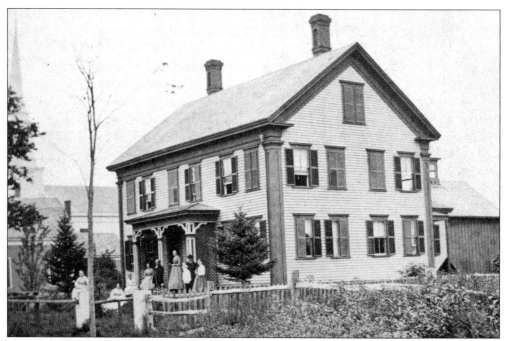

The house of H.J. Dadmun was on the southeast corner of Esty and Summer Streets. It was originally the home of Ezra Morse. The old Baptist church spire is visible in the background.

George T. Higley's house is shown here in 1900. It was built in the late 1800s on the northwest corner of Alden and Central Streets. The Zetterman family lived there in the 1940s and 1950s.

A Mr. Wiggins built this house in 1875. It is located on the east side of Main Street, near the center of town. Dr. Gaines, the only doctor in town in the 1930s and 1940s, lived here.

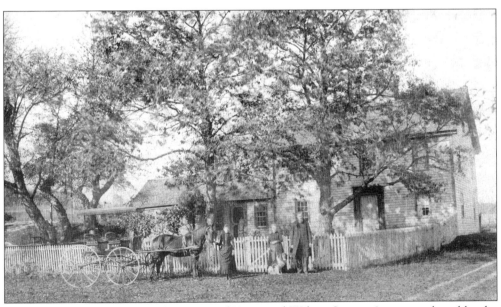

The Doubleday house was at the corner of Howe and Wilson Streets. It was purchased by the Metropolitan Water Board in 1887. The site is now part of the Hopkinton Reservoir.

This was the home of F.H. Moulton on Railroad Avenue (now Homer Avenue). It is typical of many houses built in Ashland in the latter part of the 19th century.

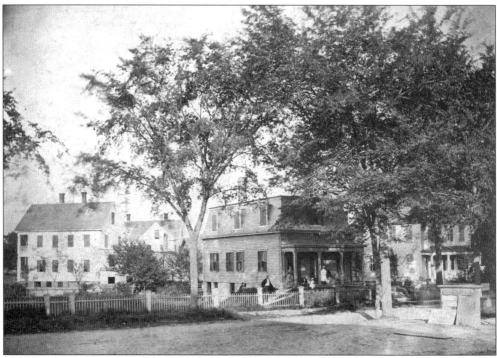

Located on Main Street across from the Grand Army of the Republic building, this was the Thayer family home. It was later owned by Billings, who ran a dry goods store there. Buildings on Railroad Avenue are visible behind the house.

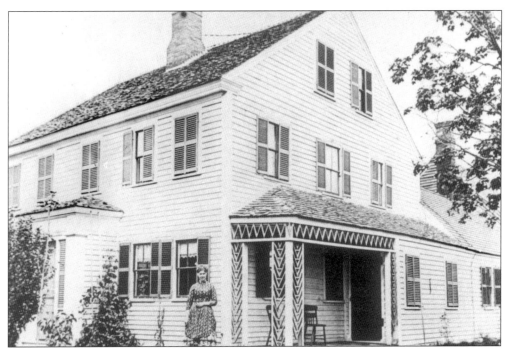

One of the town's oldest homes, this house was built by Zachias Ballard *c.* 1770. It is on Fountain Street, near the intersection with Concord Street. In 1875, it was remodeled by Mrs. Edward Ward, who appears in the photograph.

This picture was taken by John Wenzel in the spring of 1898. It shows a view of the millpond from the piazza of the Butterfield house on Pleasant Street.

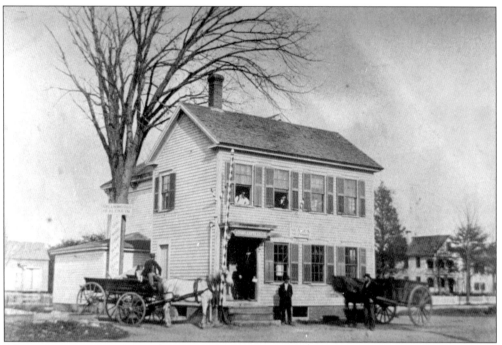

Abner Greenwood ran his anthracite coal business from this building on the south side of Front Street. He also dealt in hay, lime, and cement.

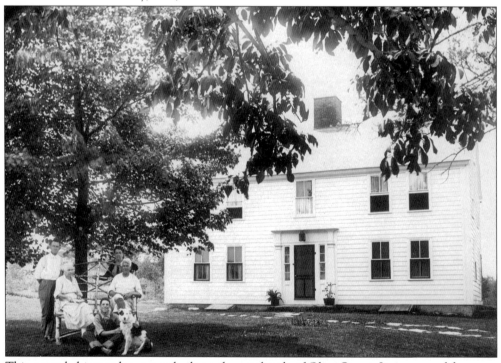

This central chimney house was built on the north side of Olive Street. It was owned for many years by the family of Everett Morey, who is seated with his wife in this c. 1925 photograph. Morey was a selectman from 1927 to 1933. (Courtesy of Robert Hebden.)

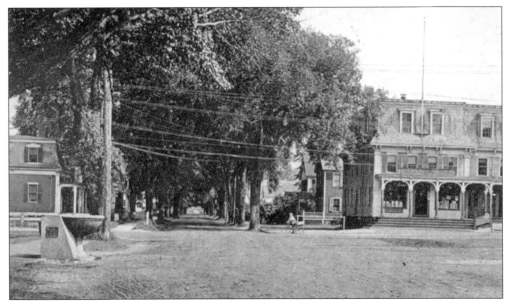

This *c.* 1915 view of the center of town is looking south on Main Street. Summer Street enters from the right. The three-story building on the corner had stores on the first floor, offices on the second, and the Grand Army of the Republic meeting hall on the third. The horse trough was put in place shortly before the street was paved for the first time. It survives today in a different location. Many of the village streets were lined with large chestnut and oak trees.

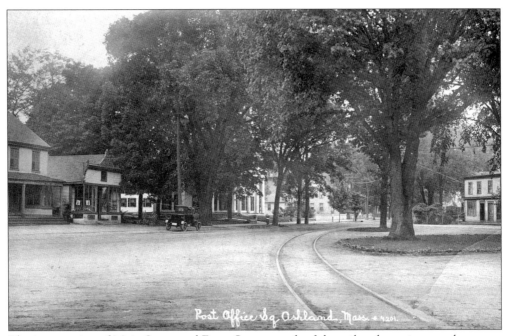

The intersection of Main Street and Front Street, north of the railroad crossing, was known as Post Office Square. The Ashland Community Building with its Greek Revival columns is visible in the center, and the Ashland News Store is on the left.

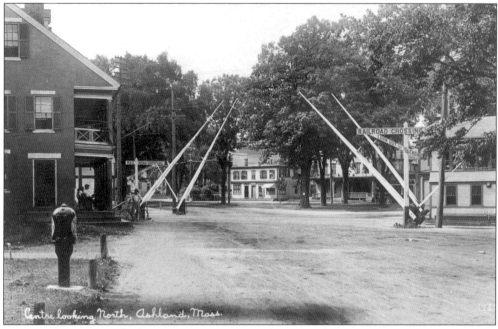

In 1915, this view north along Main Street shows the railroad crossing and the Ashland Hotel on the left. The railroad control tower is on the right, and buildings on Front Street are in the distant center.

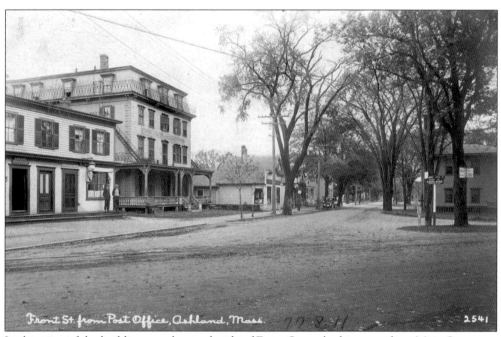

In this view of the buildings on the north side of Front Street looking east from Main Street are the post office in a hardware store on the corner, Wilcox's Central House Hotel, and Whittemore's drugstore. This photograph was taken c. 1915.

Farther along on Front Street in this 1915 view is the home of J.E. Woods. He moved his grocery business from the Greenwood Block into this house for a while. After the Central House fire, the Club Erie Castle restaurant purchased the property. The 1864 Rodman cannon is in front of the Ashland Public Library.

This was Granville Clark Fiske in 1892. He and his father supplied ice from two icehouses on Concord Street. He was very active in town affairs. He was elected selectman in 1886–1887 and state representative in 1892. A Civil War veteran, he served a term as state commander of the Grand Army of the Republic.

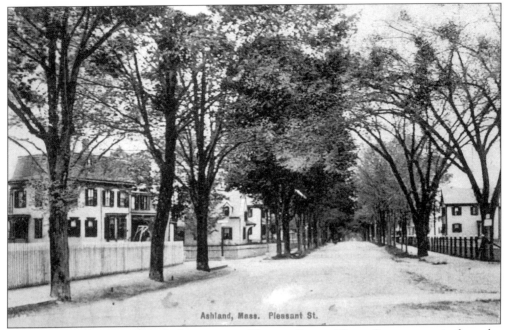

Ashland, Mass. Pleasant St.

This picture, taken in 1910, is looking west on Pleasant Street. Cherry Street comes in from the left. The large house on the left belonged to W.B. Pike. It was moved across Cherry Street to make room for expansion of Albert Ray's house.

John Wenzel was town clerk in 1894–1896. He was the stepson of Judge George T. Higley. He and his young family moved to Yonkers, New York, c. 1900.

William Franklin Merritt was Ashland's postmaster from 1891 to 1895. He was born in Ashland in 1846, the year of the town's incorporation. During the Civil War, he served in the 42nd Volunteer Regiment. After the war, he was employed in various boot factories in town. He held the position of town clerk from 1896 until he died in 1905.

Walter G. Whittemore, 1867–1942, was the town's pharmacist from 1890 until 1942. His store was on Front Street. He served as town clerk from 1906 until 1942 and was a representative to the state legislature in 1909.

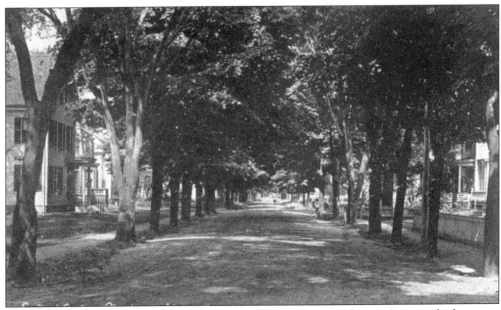

Another of the tree-lined streets in Ashland was Central Street. This 1910 view is looking east from Main Street. This was one of the last streets to lose its leafy canopy.

Horace Herbert Piper was a representative in the state legislature in 1913. He was the second president of the Ashland Historical Society. By occupation, he was a blacksmith. His shop was on Concord Street.

Three
TOWN SERVICES

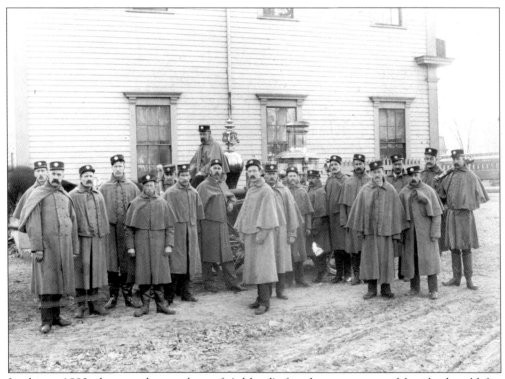

In this *c.* 1890 photograph, members of Ashland's fire department stand beside the old fire station and around the Ashland No. 1 steamer engine. Their garb features Civil War surplus blue, woolen coats with capes. Most of the men were Civil War veterans.

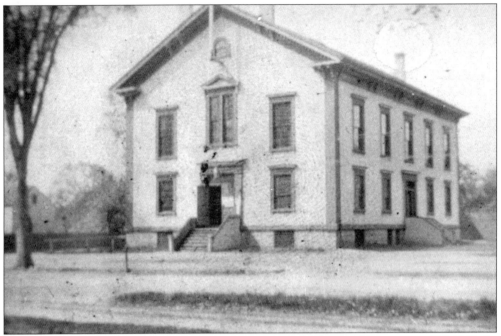

This picture shows the Ashland Town Hall as originally built in 1855 at a cost of $10,000. In the basement were two schoolrooms, a lock-up, and a garage. There were four schoolrooms on the first floor and, on the second floor, a meeting hall and two anterooms.

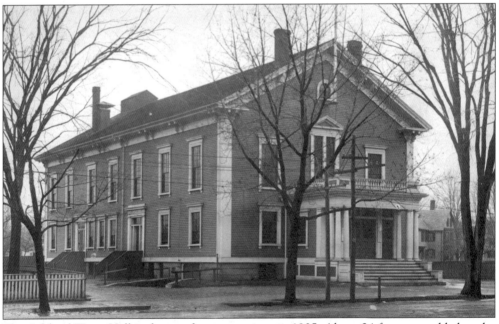

The Ashland Town Hall is shown after renovations in 1905. About 24 feet were added to the rear of the building, a stage upstairs in the meeting hall, and a columned portico to the front entry. The building was renovated again in 1981.

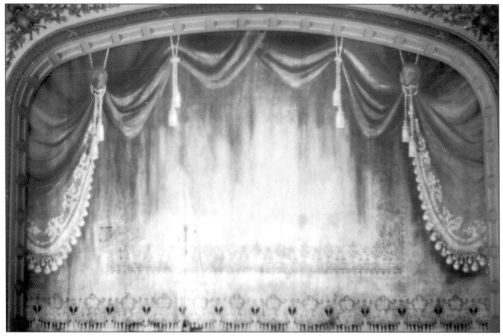

This old photograph shows the elaborate, fireproof curtain on the stage in the upper Ashland Town Hall. It was a fully equipped stage. Many musical and theatrical events were held here as well as movie shows, school graduations, and socials. It was the site of all town meetings for about 100 years.

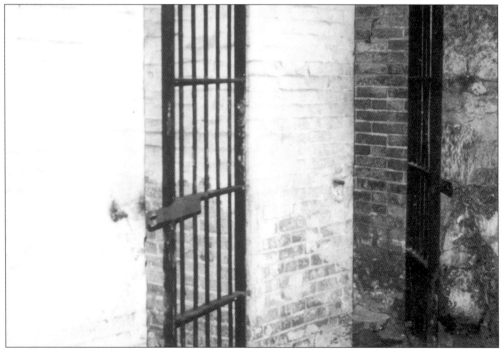

Located in the basement of Ashland Town Hall are two brick jail cells. They were used as lock-ups for the short-term detention of lawbreakers.

VOTE FOR ABRAHAM LINCOLN

TO THE VOTERS OF ASHLAND:

When it was first suggested to me to become a candidate for Selectman, I was inclined to refuse the honor, but upon representations made to me by a large number of citizens of the necessity for and the propriety of those having the welfare and interest of the town at heart, assuming the duties and responsibilities of public office, I decided to permit my name to be presented.

It should be customary and I believe it proper for a candidate for the office of Selectman to state to his fellow citizens his qualifications and the purposes of his candidacy.

My name is Abraham Lincoln, and, like my illustrious namesake I was born a country boy of poor but honest parents. I have always been mindful of the honorable name I bear, and of the rugged honesty and uprightness of my great namesake. I have patterned my life after his, and, while I have never aspired to the office of President of the United States, I have always aspired, in my dealings with my neighbors, to deserve the title of ''Honest Abe.''

I have lived in Ashland all my life, I was educated in its public schools, and was graduated from its High School. In Town affairs I have always been watchful and interested, but I have never allied myself with any faction. I believe in honest, economical and efficient administration of Town affairs.

I believe that sessions of the Board of Selectmen should be public, and that suggestions from citizens should be invited and welcomed.

I believe that the Town should get value for every dollar it expends, just the same as an individual. If elected, I pledge myself to see that this is done.

If you believe in honest, economical, and efficient administration, I ask you to vote for me, and I promise by my vote and voice to reflect credit upon your judgment and upon the great name which I bear.

Yours truly

ABRAHAM H. LINCOLN.

Winter Street, Ashland, Mass.

After this election, a card of thanks appeared in the local paper: "I wish to thank every voter, who at the polls on Monday, did not vote for me, thereby saving me the trouble and abuse which one has when elected. With one faction with their knives and poison and another with misrepresentations and false statements, the wonder is not at the small vote, but that it was as large as it was. It proves that there are 141 voters in Ashland who use their own judgment and do their own thinking. I appreciate and thank them for their trust and confidence." It was signed "Abraham Lincoln" (Ashland's own).

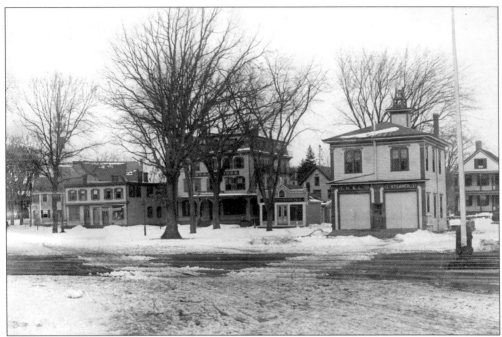

A fire station was built in 1870. It was a two-story building situated between Front and Main Streets with two doors facing the railroad crossing. There was a tower for drying hoses. A bell was added to the tower in 1878.

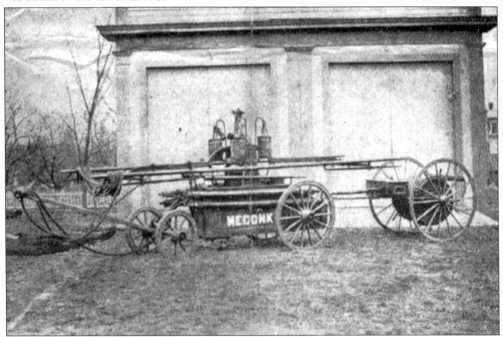

The town's original firefighting equipment was a horse-drawn, wooden hand pumper called the Magunko. It was built in 1826 and purchased second-hand prior to 1846. A dispute with Hopkinton over ownership involved raiding parties from both towns. The Magunko was relegated to storage beneath the Ashland Town Hall in 1872 and was scrapped in 1892.

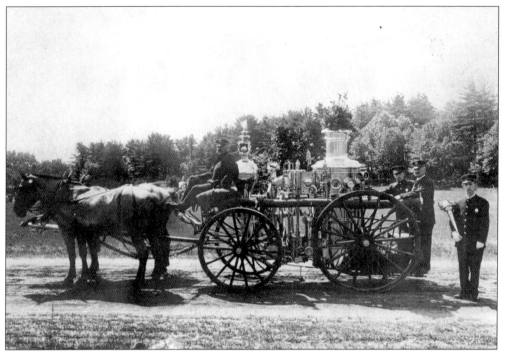

In 1871, the town purchased a steam-driven fire engine from the Amoskeag Manufacturing Company in Manchester, New Hampshire. Called Ashland No. 1, it cost $7,500 and saw long service. It was sold in 1926 and is maintained in operating condition today by an insurance firm in Nashua, New Hampshire.

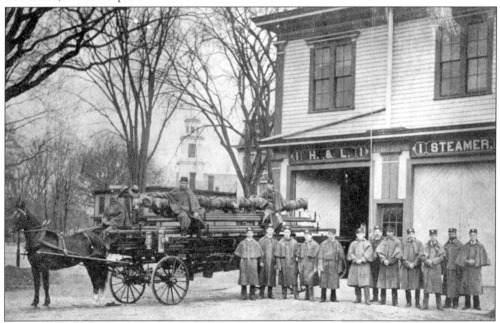

A hook-and-ladder truck was needed. Craftsmen in Ashland built one in 1873 and named it the James Jackson Ladder Company in honor of a prominent figure in the town. The driver is D.A. Corbett. Seated atop the wagon is Capt. A.W. Brooks and Steward H.A. Hogan.

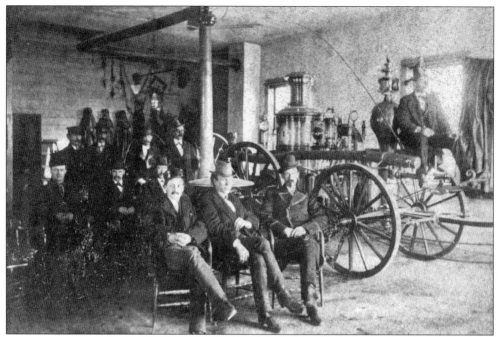

This photograph shows the interior of the fire station. It was always a meeting place for members of the fire company. The station was known for socials held upstairs, at which an excellent clam chowder was served.

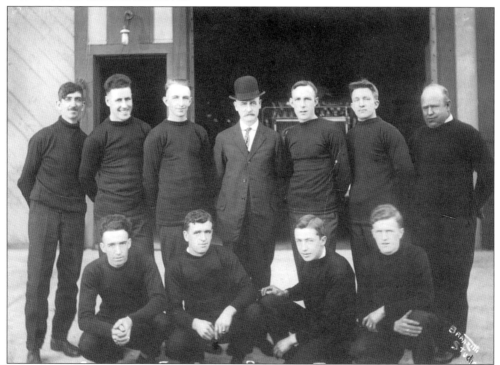

This 1920 photograph is identified as the Ashland Fire Department running team. It seems likely that rather than road races they probably competed in firemen's musters.

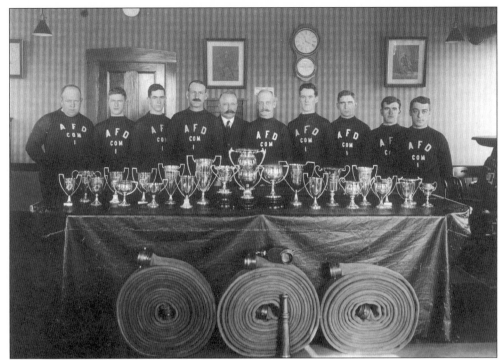

This is another photograph of the 1920 Ashland Fire Department displaying a collection of hardware inside the old station. From left to right are Wenzell, Walkup, MacNear, MacNear, Murphy, Reall, Kavanaugh, Ryan, Walkup, and Scott.

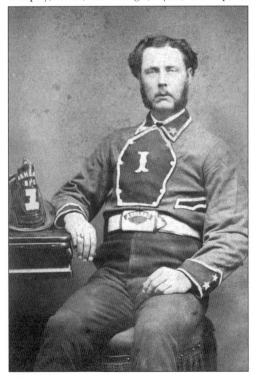

Granville C. Fiske was a member of the Ashland Fire Department. He shown c. 1880 arrayed in his Engine No. 1 uniform.

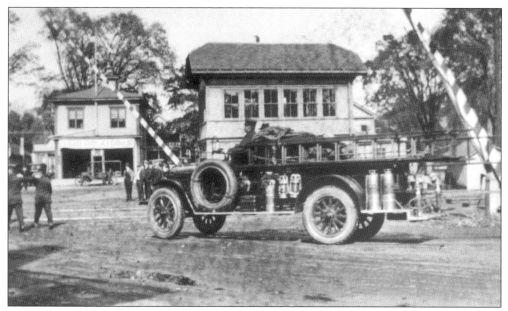

This Maxime engine brought 1,700 feet of hose to a fire. It had two pumps capable of 600 gallons per minute. The old fire station is visible beyond the railroad control tower.

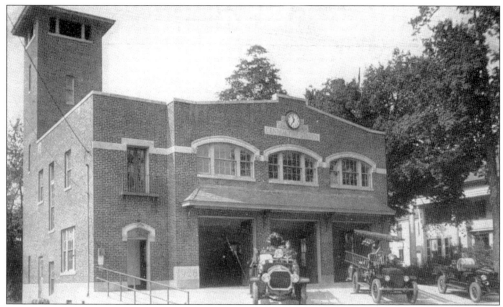

A new fire station was built in 1928–1929. It was located across the street from the old station on the west side of Main Street. It was a two-story, three-bay brick building and continues to serve the town today.

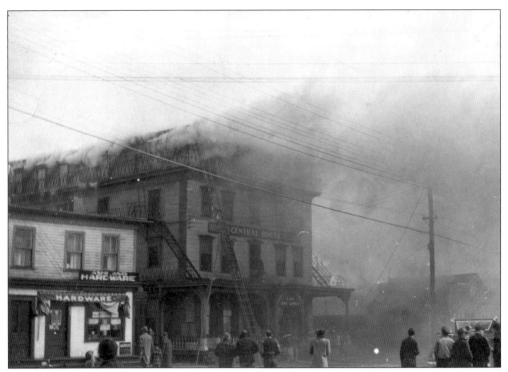

Ashland has had its share of devastating fires. This one in March 1944 destroyed the Central House Hotel and Club Erie Castle on Front Street.

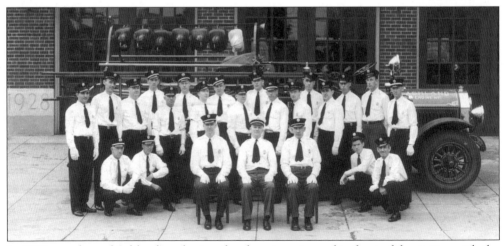

In 1940, members of Ashland's volunteer fire department posed in front of the station with the Maxime pumper truck. The Ashland Fire Department was a volunteer one until November 1963, when the first permanent firemen were authorized.

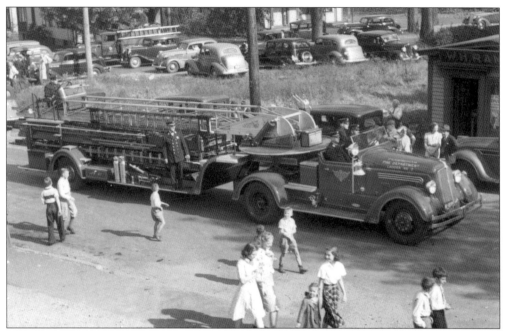

This American LaFrance ladder truck could reach the roof of any building in town. It appears here in a 1937 parade. It is on Summer Street with Main Street in the background. The Grand Army of the Republic building is gone, leaving an empty lot. The little shop of W.H. Ramsey is just visible on the right.

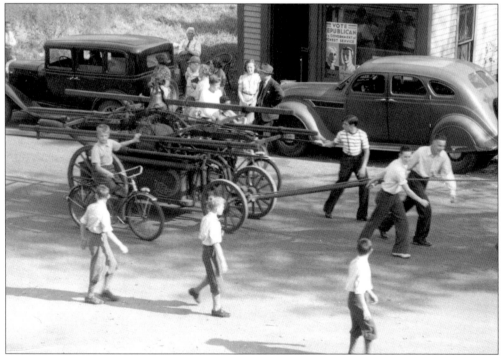

This unidentified hand pumper appeared in the 1937 parade. It was typical of the fire equipment in use 100 years earlier.

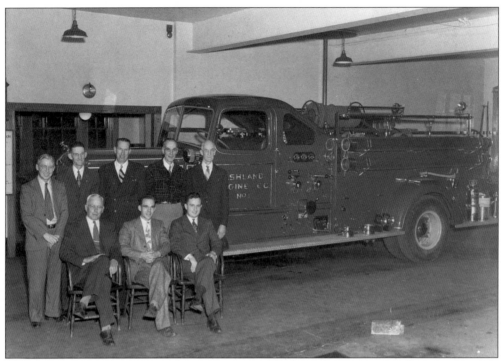

Selectmen, seated from left to right, are Martin Mulhall, Carleton Stone, and George Tegelar, posed with fire engineers Leslie Morse, George Taylor, Donald Clark, Ken Bradstreet, and Ernest Dearborn in 1947. They are inside the station with the new Mack pumper.

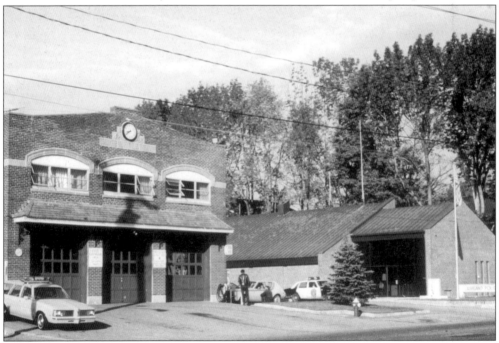

This photograph shows the public safety complex on Main Street. The three-bay fire station was joined by a new police station in 1977.

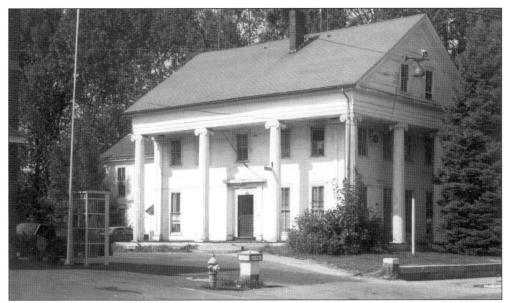

The Ashland Community Building housed several departments of town government. The police station was on the second floor. The building was constructed by Dr. Harris in 1847 as his home and office and occupied by John Clark, Dr. George Butterfield, Dr. William Barrett, Dr. Wood, and Dr. Roy Morse. Telechron Associates purchased the building in 1930 for use as a clubhouse. Deeded to the town in 1951, it was demolished in 1977. It was replaced by the Ashland Police Department headquarters.

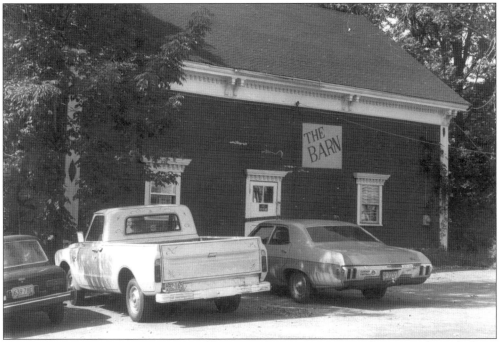

Behind the Ashland Community Building was the Barn. Renovated in 1930 by Telechron Associates as a gymnasium, it was used later for club meetings and youth group events. The Ashland Police Department parked a cruiser under the building.

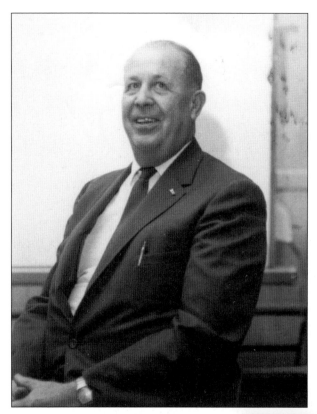

Walter F. Schouler was a policeman for over 40 years, resigning in 1967. He was police chief for 26 years and the only full-time officer until 1947. Telephone calls to the department were answered by Chief Schouler's wife in their home.

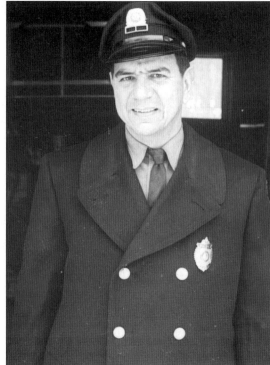

Harry Marchetti joined the police force just after World War II. He was a popular figure, known to everyone in town. For many years, his duties included that of youth officer. He is shown here in 1966.

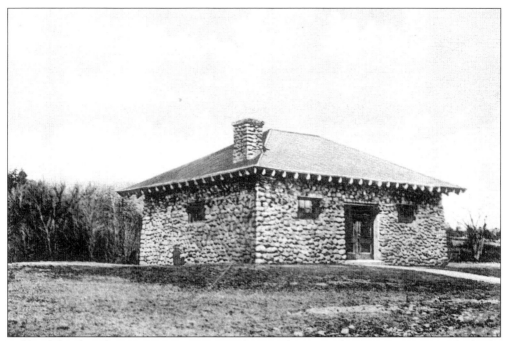

Ashland developed a water system in 1911. This was the original pumping station on the banks of the Sudbury River off Fisher Street. Drawing water from a field of 12 shallow wells, it fed the piping system and a standpipe on Brewer's Hill off Myrtle Street.

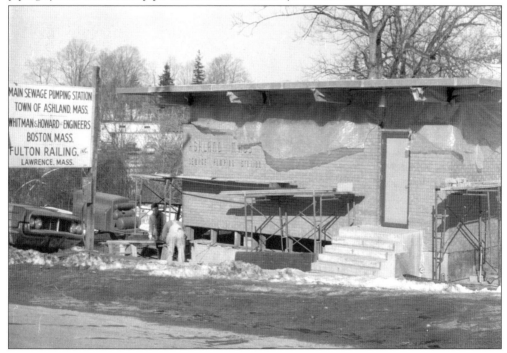

A system of sewers was established in 1966. Here, the main pumping station on Chestnut Street is shown under construction. From this point, a portion of the town's sewage is pumped to Framingham and eventually to Nut Island on Boston Harbor.

Edward J. Billings served as town clerk from 1880 to 1890. A town library was set up in the Ashland Town Hall in 1881. In addition to his other duties, Billings acted as librarian.

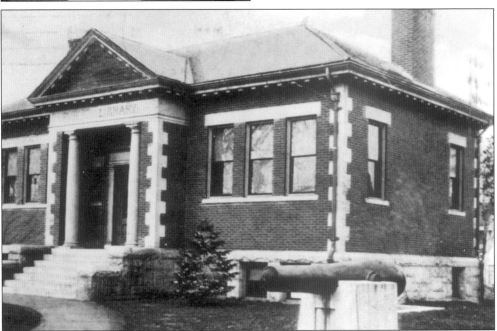

In 1904, with $10,000 from the Carnegie Foundation and land donated by Abner Greenwood, a public library was built on Front Street. The cannon was set in place as a Civil War monument by the local Grand Army of the Republic post in 1908. The only significant alteration of the building was in 1962, when a small addition was attached to the northwest corner.

Ella M. Wiggin was librarian from 1891 until 1900. She served on the library's board of trustees for 12 years as well. She donated funds for the purchase of the shelving in the library's stack room.

Land for a public library was donated to the town by Abner Greenwood, who had been opposed to the project originally. Greenwood was a prominent local businessman with a thriving coal business. The donated land abutted his three-story brick building on Front Street.

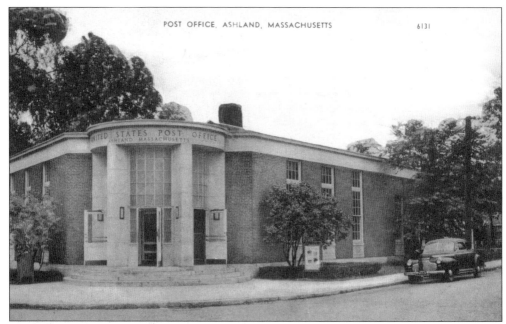

A post office first opened in Unionville in 1835. It occupied various locations in the town center over the years. In 1940, a permanent building was erected at Main and Summer Streets. Anna L. Cavanaugh had been postmaster since 1936 and continued in that post in the new facility.

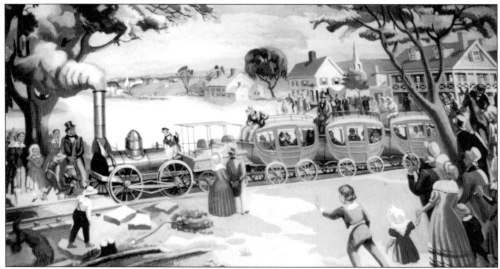

In the Ashland Post Office, on a wall above the postmaster's office, a mural was painted as a Works Projects Administration project. It depicts the arrival of the first train at Unionville in 1834. It was a big event attended by Daniel Webster and Gov. Levi Lincoln, who made speeches. A collation followed the ceremonies in Stone's Hotel. The artist took some license. One notable item is the direction of the train. There was a single track with no provision for reversing the train's heading. It had to be backed to Framingham before being turned around.

William H. Twiss was postmaster in Ashland from 1900 to 1916. He was the third president of the Ashland Historical Society.

The fifth postmaster was Caleb Holbrook. He succeeded Adrian Foote in the position. Holbrook's term ran for six years, beginning in the Cleveland administration. He also served as representative in the state legislature in 1883.

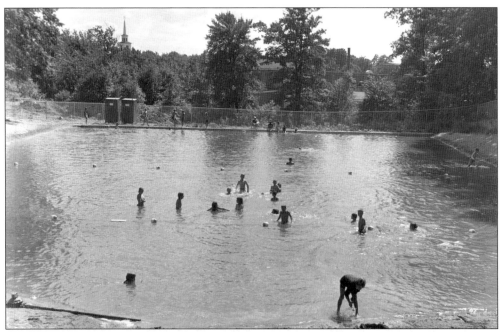

A Works Projects Administration project in Ashland constructed a swimming beach on Granite Street (now Raymond Marchetti Street), adjacent to the Sudbury River. It was completed in 1938 and was in operation for a number of years before closing. It reopened briefly in the 1960s, when this photograph was taken.

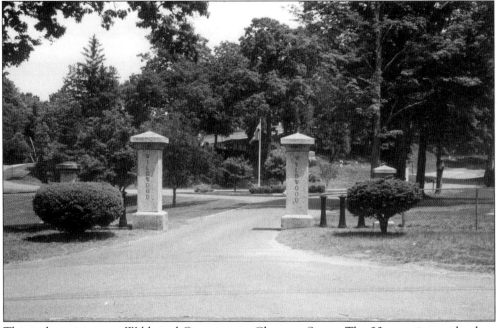

This is the entrance to Wildwood Cemetery on Chestnut Street. The 23-acre site resplendent with oak and chestnut trees was purchased from Charles Alden. It rises from the banks of the Sudbury River and provides panoramic views of the town. Lots were laid out along a system of roads and paths. Dedicated in 1870, it continues serving the town today.

Four
SCHOOLS AND SPORTS

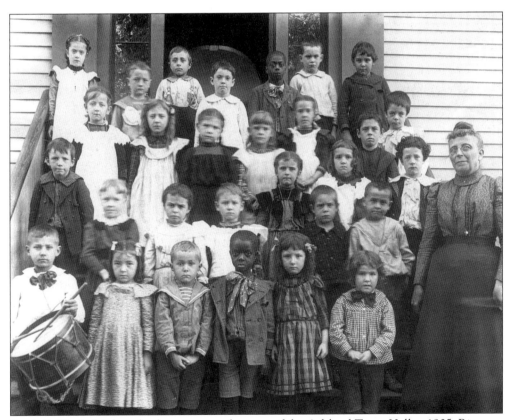

Sarah F. Rice's third-grade class poses on the steps of the Ashland Town Hall *c.* 1905. Rice was a graduate of Framingham Normal School. She taught for 43 years, all but two of them in Ashland from 1870 to 1911.

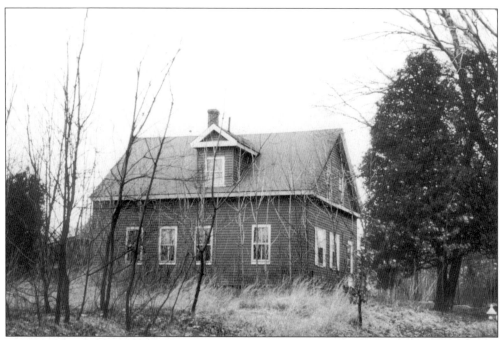

In 1846, the new town was divided into seven school districts. This was the 2nd District School on Olive Street. The building is a private residence today.

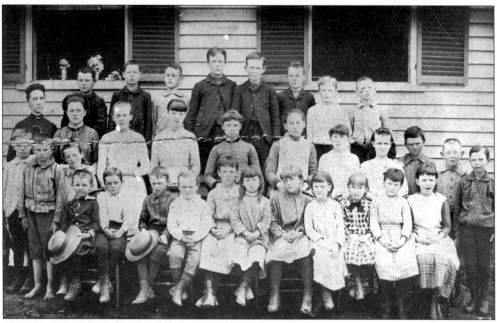

This class poses outside the 7th District School on Cedar Street. Emily Herndon was the teacher. The building was always too small for the number of students attending. Impatient with the town's delay in remedying the situation, students dismantled the building, forcing the town to build a new one.

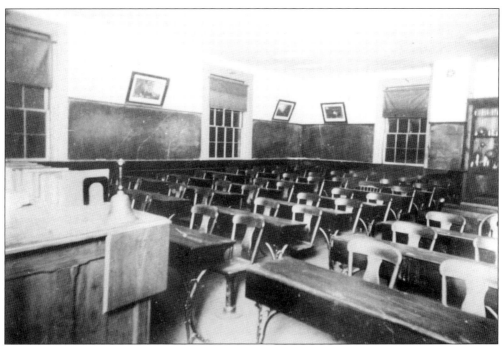

The high school class occupied this classroom in Ashland Town Hall until 1889. It was one of the front rooms on the first floor of the building in the northeast corner.

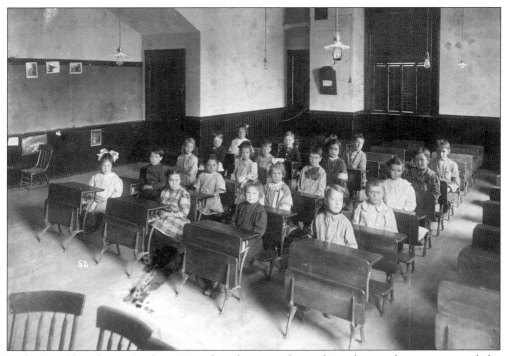

Katherine Shaughnessy's class is in the classroom located in the southeast corner of the Ashland Town Hall. The photograph was taken in the spring of 1912. Eight of this class finished grammar school and five of them graduated from Ashland High School in 1923.

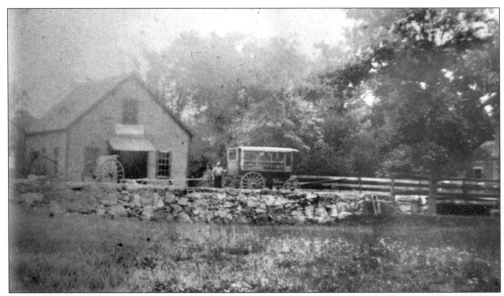

Photographed *c.* 1905, this horse-drawn vehicle was known as the school barge, forerunner of today's school bus. The locale is on Concord Street, near Piper's blacksmith shop and the bridge over the Sudbury River.

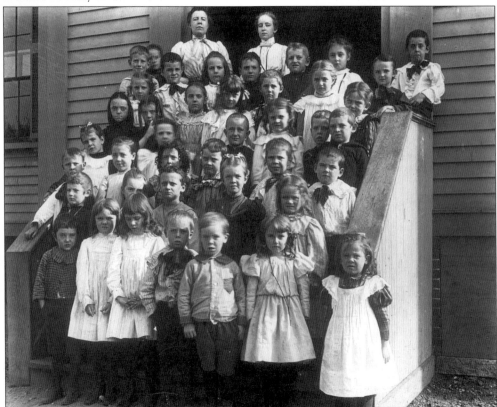

This was an early elementary school class. The photograph was taken outside the Ashland Town Hall.

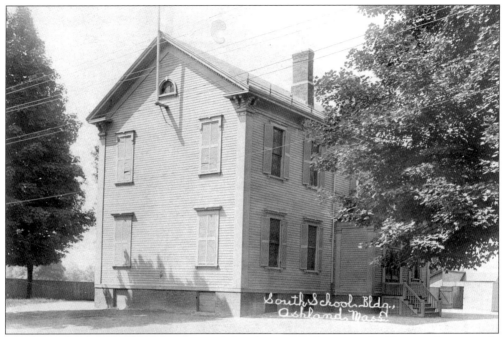

In 1871, some district schools were consolidated in a new, four-room building on the west side of South Main Street. It was known as the South School and housed fourth-grade, fifth-grade, and sixth-grade classes up to 1928. It was torn down c. 1932. Note the privies to the rear of the building, a constant problem.

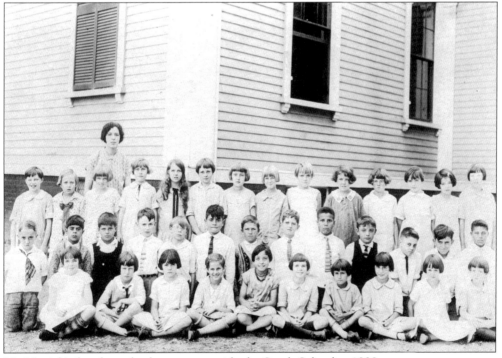

Ms. Novick's fourth-grade class poses outside the South School c. 1928.

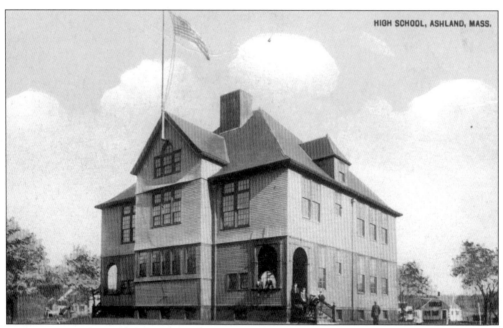

Built in 1889, the Ashland High School was located on the southeast corner of Central and Alden Streets. High school classes were held on the upper floor while seventh and eighth grades occupied the lower floor. This photograph was taken prior to 1928.

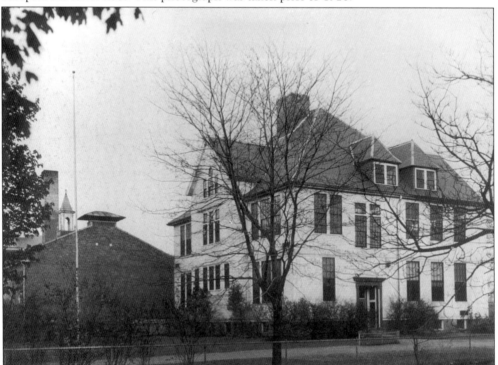

Ashland High School is shown in the mid-1940s. The building had undergone some alterations since being built in 1889. To the left, beyond the flagpole, is the Central Street School. (Courtesy of Robert Hebden.)

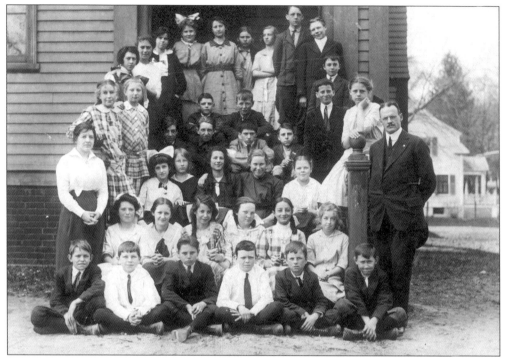

This is a seventh-grade class outside the high school. The teacher was Helen Trevas. Superintendent William Putney is on the right.

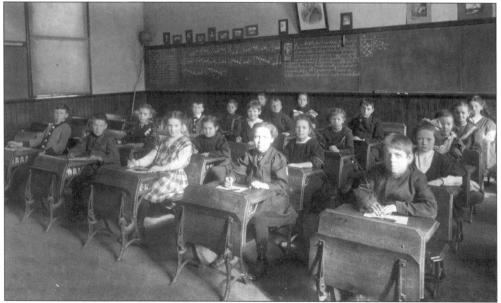

This c. 1900 picture shows an unidentified South School class.

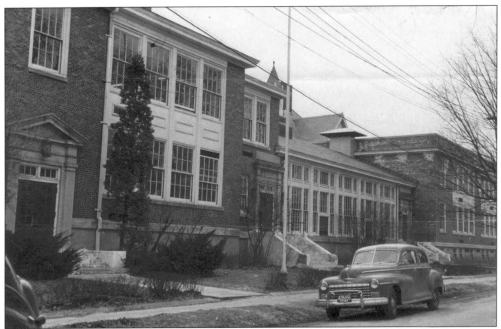

The Central Street School is shown in 1949. The section to the far right consisted of four rooms and had just been added. In 1929, the 12 classrooms to the left and the gymnasium had been built. The high school building roof is visible to the rear of the new addition. (Courtesy of Robert Hebden.)

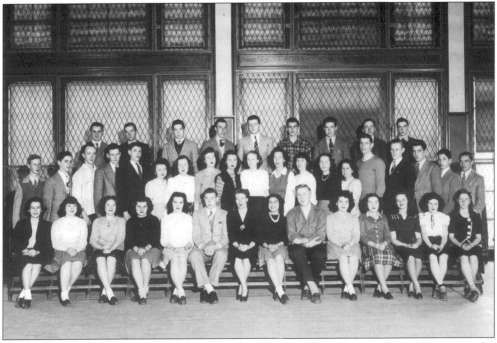

This photograph of the junior class was taken in 1947. The location was the gymnasium at the Central Street School. Miriam Riley, the teacher seated front center, left the Ashland schools to serve in the U.S. Women's Army Corps during World War II.

Ms. Dearborn's fifth-grade class was photographed in the Central Street School in 1929. The doors to the rear of the room opened to the coat closet.

These were sixth- or seventh-graders at the Central Street School c. 1930. Note the frosted glass in the door except for one clear pane.

George A. Bennett, Mildred B. Stone, and Martin C. Mulhall had just completed first grade in 1919. They had maintained perfect attendance records.

Charles "Doc" Whitcomb was the teacher of this eighth-grade graduating class in 1926. The boys were William Holmburg, Milan Miller, Charles Horne, Robert Thayer, Earle Howard, and John Boscilla.

Shown here is the 1900 grammar school graduating class. They are, from left to right, as follows: (front row) Margaret Acton, Theresa Kavanaugh, Carrie Parcell, Nina Adams, and Agnes Carey; (back row) Pearl Davis, Alice Ray, Joseph Carey, Jennie Kavanaugh, and Ida Brewer.

The grammar school graduating class of 1910 poses with their teacher, Estelle Provan (front row, center).

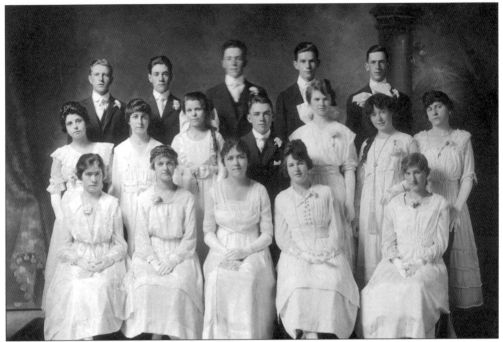

Another class (probably high school) poses for a graduation picture *c.* 1910.

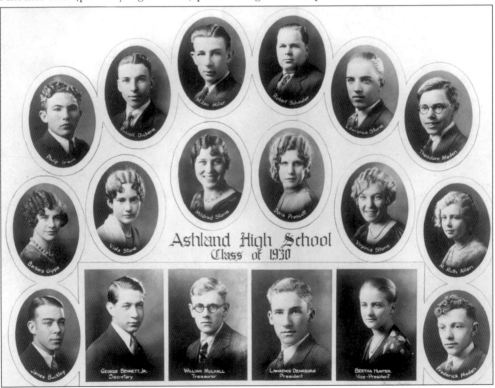

This was Ashland High School's 1930 graduating class. Many of the surnames, such as Stone, Mulhall, Buckley, Maden, Dearborn, and Miller, are familiar ones.

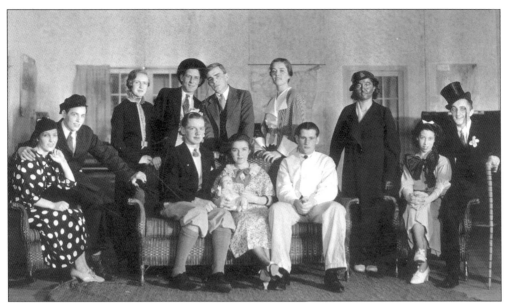

The 1934 senior class play was performed on the stage at the Ashland Town Hall. Names of the cast members included Giargiari, Walkup, Bushee, Buckley, Gates, Morse, and Dakai.

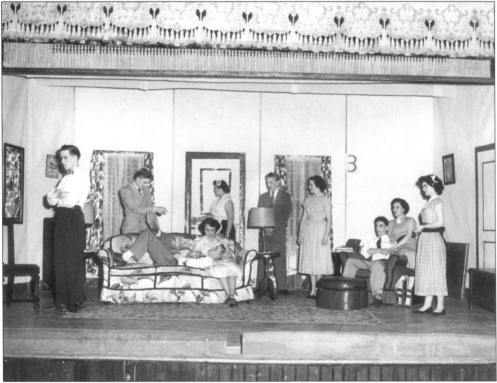

The Ashland Town Hall was again the venue for this senior class play in 1952. The yearbook does not mention the name of the play. It does say that it was a big success. On opening night, everything was running smoothly when the cover of the large chest fell with a loud bang, nearly causing the young actor standing next to it to pass out.

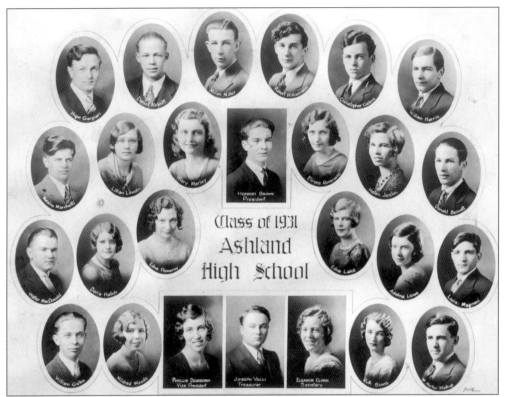

Twenty-six young men and women constituted the Ashland High School Class of 1931. Note that Milan Miller managed to appear in both the 1930 and 1931 pictures.

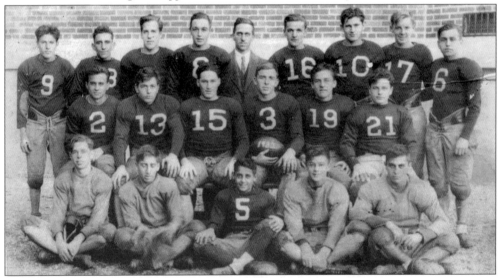

Coach Harold Walker's 1931 Ashland High School football team poses here. From left to right are the following: (front row) Sigmund Durmer, Al Awad, Louis Ferdenzi, Philip Holden, and Mitch Camille; (middle row) Ti Ferdenzi, Mando Giargiari, Parker Halpern, Joe Buckley, Ray Boniface, and Alvin Halpern; (back row) Charles Borelli, Koki Cerutti, Morton Lewis, Clyde Cristman, Coach Walker, Joe Cunis, Alex Dakai, Roy Holmberg, and Nesti Giargiari.

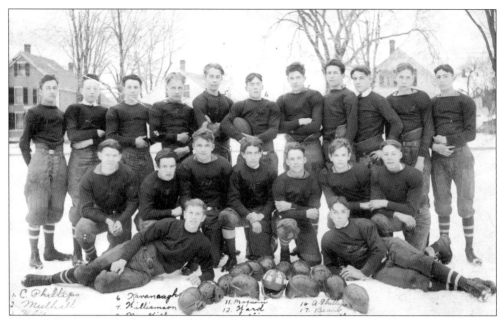

In the fall of 1924, the high school football squad poses at Stone Park. They are, from left to right, as follows: (front row) Carlson and Holly; (middle row) Ward, Sullivan, Cunis, Hogan, A. Phillips, Beard, and Lowell; (back row) C. Phillips, Mulhall, Whittemore, Widell, Holmberg, Kavanaugh, Williamson, McGill, Wight, Lewis, and Magnani.

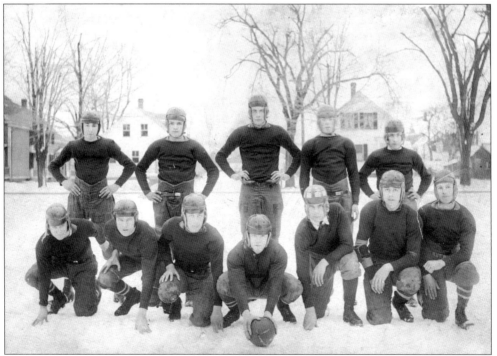

The 1927 football team featured, from left to right, the following: (front row) Vin Sullivan, Neily McGill, George Widell, Red Ward, Jack White, Carl Holmberg, and Al Phillips; (back row) Dick Whittemore, Tony Cunis, Harold Williamson, Ed Kavanaugh, and Gordon Hogan.

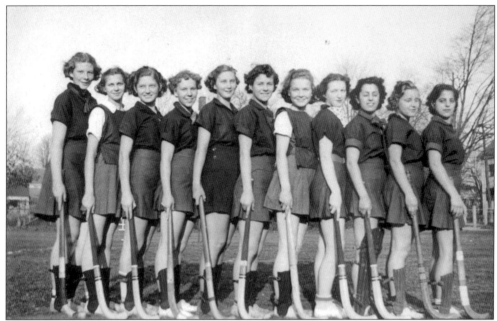

The Ashland High School girls' field hockey team, c. 1936, included, from left to right, Marjorie Clark, Irene Dzindolet, Evelyn Kimball, Arlene Marble, Lorraine Salsman, Gladies Bell, Kathryn Brown, Irene McGill, Emily Camille, Regina Cudak, and Adele Camille.

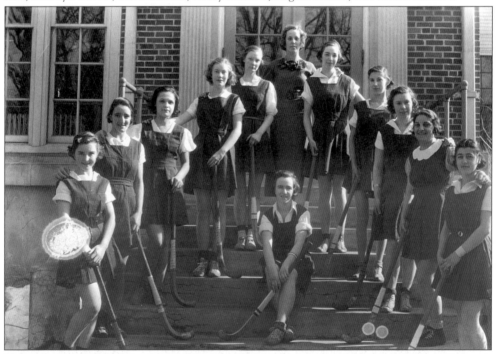

In September 1933, Ashland fielded its first girls' field hockey team. Captain Midge Walkup is seated in the center. The others, from left to right, are Maddie Brown, Adeline Magnani, Helen Rachet, Margaret Hesslink, Betty Stensson, Coach Pratt, Vera Vallavanti, Julia Kadra, Bernice Marble, Muriel Logan, and Eleanor Dickens.

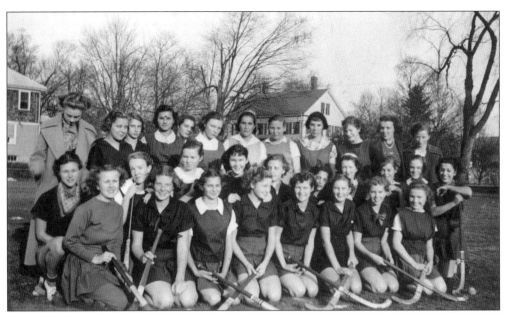

This photograph of the girls' field hockey team, *c.* 1937, appears to have been taken at Stone Park.

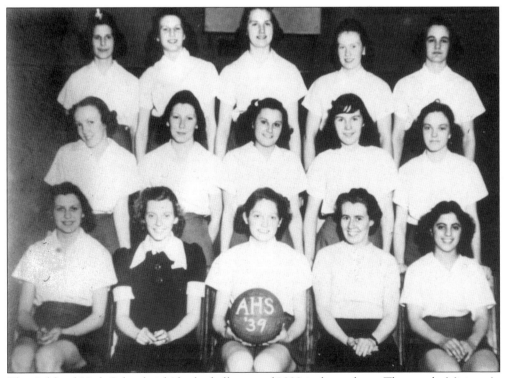

The Ashland High School girls' basketball team of 1939 is shown here. The coach, Miriam A. Riley, is seated in the front row, fourth from the left.

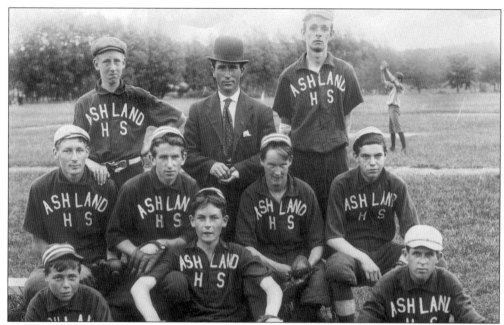

Baseball was always a popular sport in Ashland. This photograph was taken *c.* 1906. From left to right are the following: (front row) H. Shaughnessy, Jimmy Larkin, and Fred Schneider; (middle row) H. Caddy, William Sinclair, T. Murray, and Newman Dearth; (back row) Richard Murphy, unidentified, and unidentified. Richard Murphy was killed in action in World War I. A square in the center of town bears his name (see page 126).

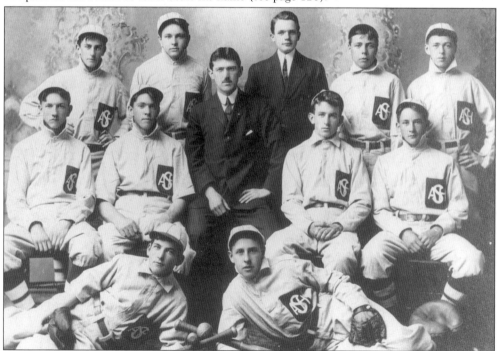

This photograph was taken *c.* 1910. The young man in front, on the left, is Ed Shaughnessy, who later served the town as town counsel for many years.

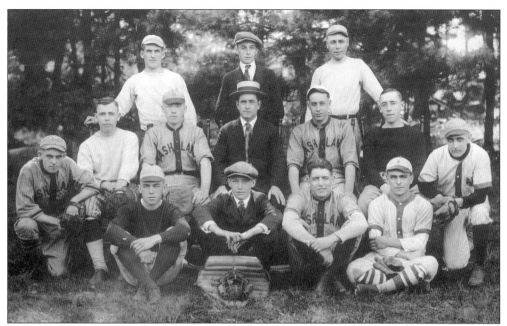

Another early Ashland baseball team posed for this photograph. Members are, from left to right, as follows: (front row) Henry Shaugnessy, Sheridan, unidentified, unidentified, James Nolan, and unidentified; (middle row) Edward King, Quigley, Thomas Murray, unidentified, and Thomas King; (back row) Edward Shaughnessy, Monty Clifford, and Fred Schneider.

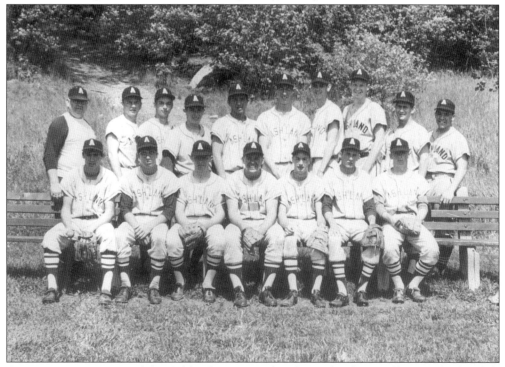

A more recent version of the Ashland nine posed with coach Clem Spillane at the baseball diamond behind the school on Concord Street.

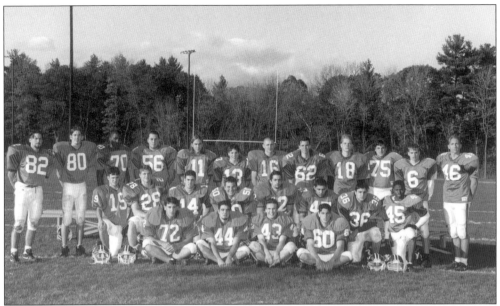

The 1995 "Clockers" football team captured the Tri-Valley League Championship and the Division 6B Super Bowl. Their season featured a 7-6 win over traditional rival Hopkinton on Thanksgiving Day. The head coach was Kevin Maines. Cocaptains were No. 72, Mark Ferrelli; No. 43, Michael Hackett; No. 44, Mark Vendetti; and No. 60, David Waldstein. There were 16 seniors on the team that year. (Courtesy of Thomas G. Waldstein.)

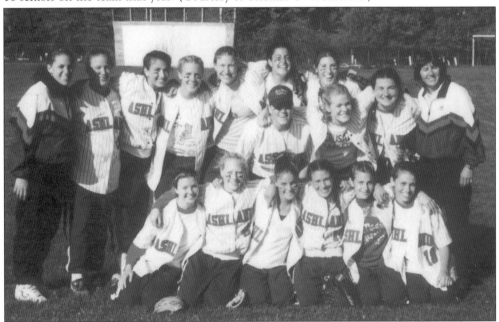

The girls' softball team in 1998 won the State Division 3 Championship for the second time in three years, defeating Frontier Regional at Worcester in an exciting 3-1 win. The team lost only four games while winning over 20. Coaches were Ginny Walsh and Charlene Carabello. Cocaptains were senior Leah Kamataris and junior Amy Curlett. Other seniors were Cori Beth, Keri Giangrande, Becky Karb, and Michele Leporarti. (Courtesy of Thomas G. Waldstein.)

Five
RELIGIOUS
ORGANIZATIONS

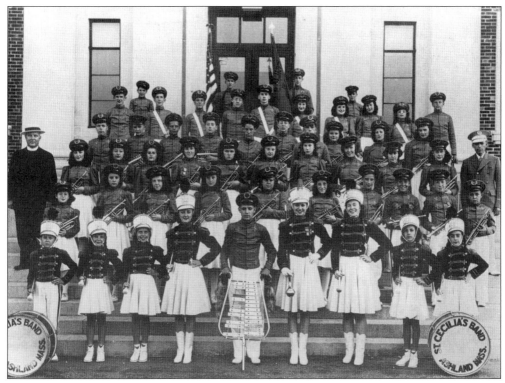

St. Cecilia's Band competed in Catholic Youth Organization events for over 10 years. Father Hartigan and bandmaster Fred Adams had them playing eight-part harmony on trumpets in championship form. They are shown here *c.* 1939 in their new uniforms.

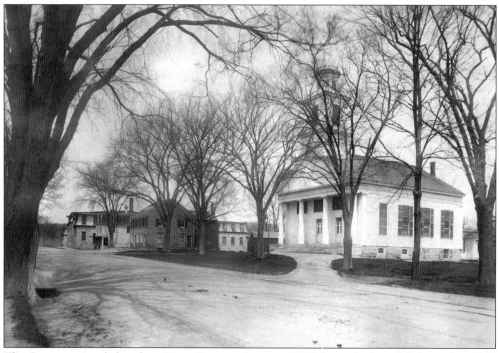

The Congregational church on Main Street is shown *c.* 1900. It was built and dedicated in 1836 on two acres of land bought by the Union Evangelical Society. In 1846, it became the First Parish in Ashland. The name was changed to the present Federated Church in 1919. Just to the north are the stone mill buildings and the brick store.

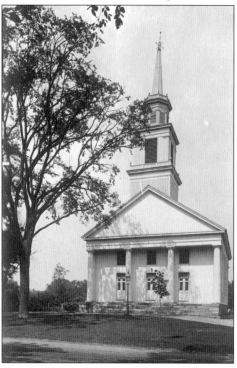

In 1870, the Congregational church was enlarged with an addition in the rear and then, in 1889, it was modernized.

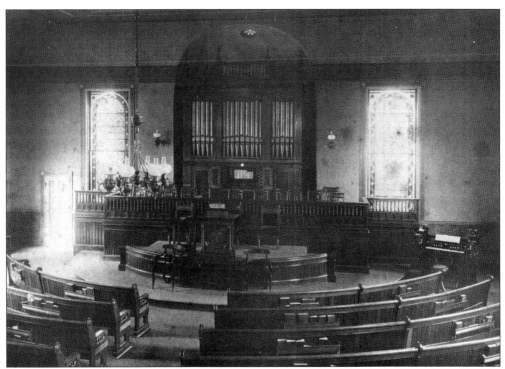

This interior view of the Congregational church was taken after modernization in 1889. Stained-glass windows were installed at this time.

Benjamin T. Thompson was a deacon of the Congregational church for many years. He worked at the Cutler grain mill, married Martha Cutler, and in 1864 became a partner in the business. He was said to have had a compassionate and generous nature. In 1913, he died at the age of 78 years.

Rev. William M. Thayer authored a series of juvenile books. He was pastor of the Congregational church from 1849 to 1856 and a representative in the state legislature in 1855.

Rev. Thomas Morong was a popular pastor of the Congregational church from 1876 to 1890. He was a recognized authority in the field of botany.

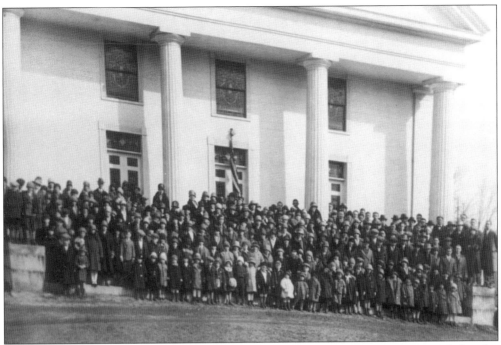

This *c.* 1925 photograph indicates the size of the congregation of the Congregational church.

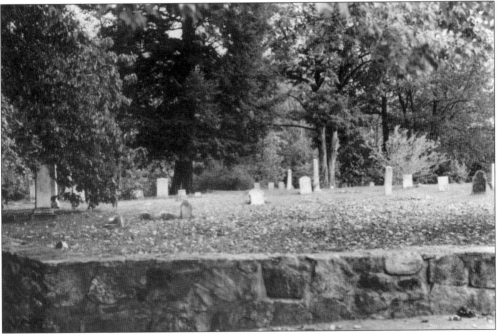

The Old Village Burial Ground occupies about two acres behind the Congregational church. It was put into use in 1838 and was deeded to the town in 1850. This cemetery became virtually inactive when the town opened Wildwood Cemetery in 1870. In fact, a number of those interred here were moved to the new location.

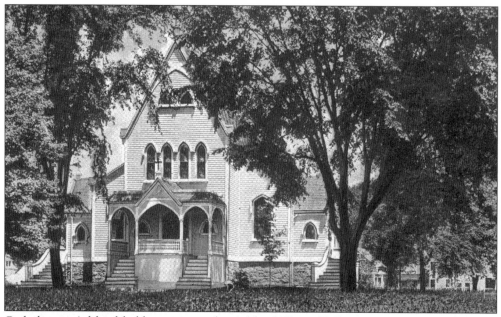

Catholics in Ashland held services in the Ashland Town Hall up to 1874. Construction of St. Cecilia's Church on Esty Street had been started and the lower hall was used until the building was completed in 1883.

Fr. Michael F. Delaney was the first priest assigned to the new parish of St. Cecilia's. There was no rectory, so he lived in the B.F. Brown house on Summer Street. Father Delaney left Ashland in 1890 after six years as pastor.

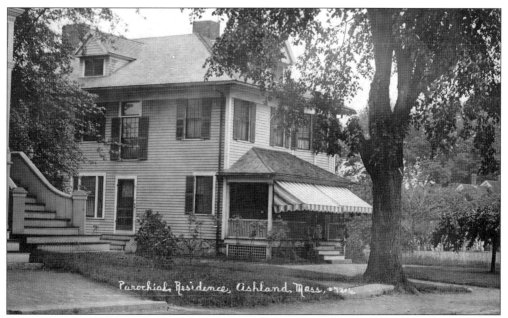

St. Cecilia's built a rectory next to the church on Esty Street shortly after 1890. The first pastor, Father Delaney, rented a room at the Central House Hotel until he was able to find a house on Summer Street to rent.

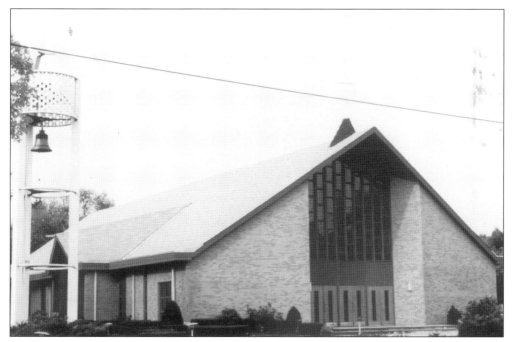

St. Cecilia's erected a new church on Esty Street opposite the rectory and original church. Completed in 1963, it had the Fr. James E. Dunford Memorial bell tower added several years later.

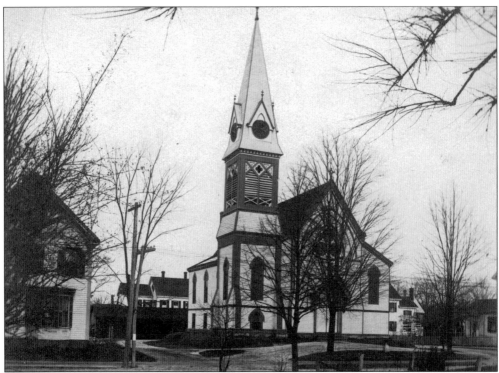

Situated on the east side of Alden Street was Ashland's Methodist church. Charles Alden provided the land. The building was dedicated in 1869. The town clock was housed in its steeple. The steeple was hit by lightning once but suffered little damage, as the rain doused the fire. The church was torn down shortly before 1930. To the left in the photograph is the parsonage.

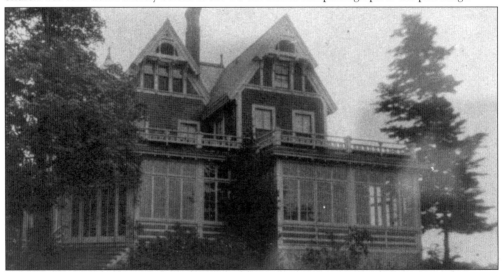

Located on about 200 acres between Cedar and Pond Streets was the Workmen's Circle Camp. Conducted under Jewish auspices from 1928 to 1949, it was a summer camp for city children and a popular social center. The administration building was the 15-room home built by the Dearth family in 1866, replete with exotic wood finishes. Known as the Mansion House for a while, this exquisite building succumbed to fire in 1961.

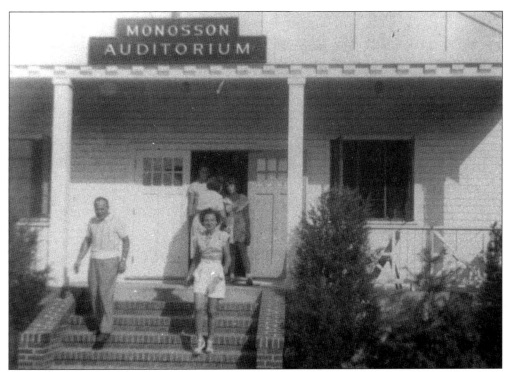

At Workmen's Circle, the Monosson Auditorium, built in 1947, was state of the art. People by the thousands would travel by automobile, bus, and train to attend weekend events featuring prominent artists and political figures here. It was destroyed by fire in 1956.

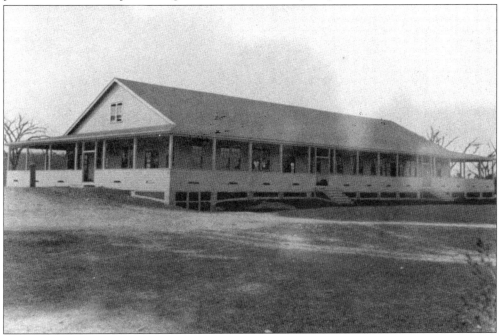

The dining hall at Workmen's Circle could serve 1,000 or more people at a sitting. Fire leveled the facility in 1957. The remote location of the camp made it susceptible to arson.

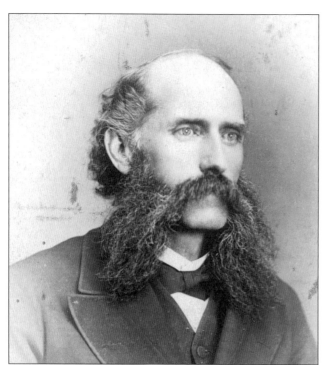

Rev. C.D.R. Meacham was pastor of the Baptist church for three years, beginning in 1883. The church was erected on the south side of Summer Street in 1850 on land purchased from John Stone. Destroyed by fire in 1900, it was rebuilt in more modest style and was referred to as the "Brown church."

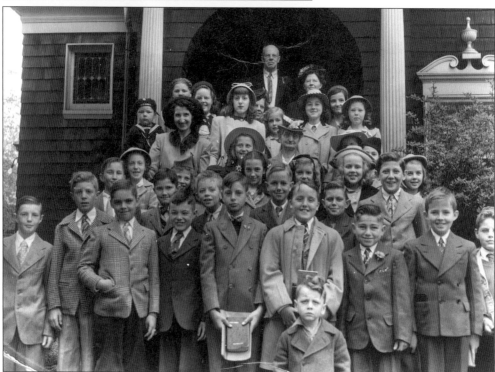

This Sunday school class posed in 1947 in front of the Ashland Baptist Church. Richard Hebden is in the front on the left. William Fuller is second from the right in the front row. In the back are the minister, Hampton Price, and Mrs. Holman. (Courtesy of Robert Hebden.)

Six
BUSINESS AND INDUSTRY

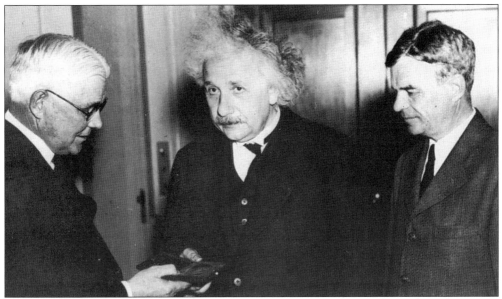

Henry E. Warren was Ashland's leading citizen in the 20th century. He is shown here, on the right, in 1935 at the Franklin Institute in Philadelphia, Pennsylvania. John Price Wetherill Medals were presented to Warren and to Dr. Albert Einstein in recognition of their contributions to science and industry.

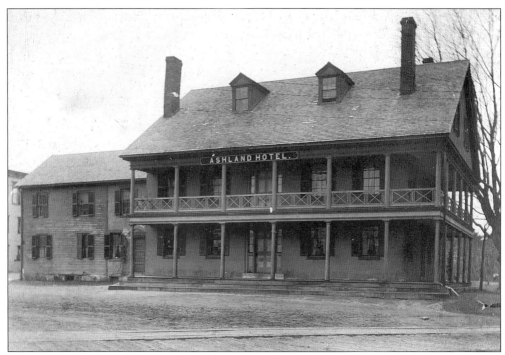

Ashland businesses included several hotels. Capt. John Stone built this one in 1834, adjacent to the railroad line on Main Street. It was known originally as the Railroad House. Stone leased it to several people over the years. W.A. Scott bought it in 1849. At the time of this photograph, it was the Ashland Hotel. It is known today as John Stone's Inn.

W.A. Scott operated a livery business in conjunction with his hotel. The stable was located on the west side of Main Street between the hotel and the Odd Fellows building.

Capt. John Stone (1779–1858) owned a considerable amount of land in the village. His family were descendants of the proprietors of Sudbury and Framingham and related to the earliest settlers of Ashland.

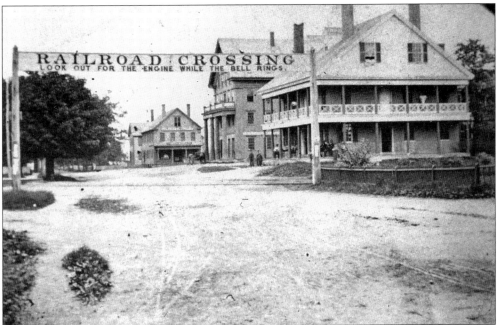

This *c.* 1890 view of the railroad crossing at Main Street shows the close proximity of the hotel to the tracks. Just beyond is the Odd Fellows building and, in the distance, at the Main and Summer Streets intersection, is the Grand Army of the Republic building.

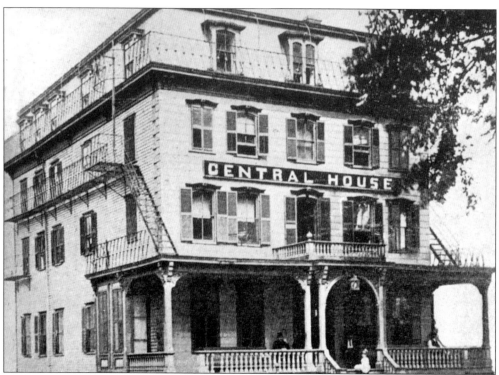

The best known of Ashland's hotels in the 19th century was the Central House. It was built by O.A. Wilcox on the north side of Front Street *c*. 1869. It was renowned for its dining room and décor. Bostonians would travel out by train to dine there.

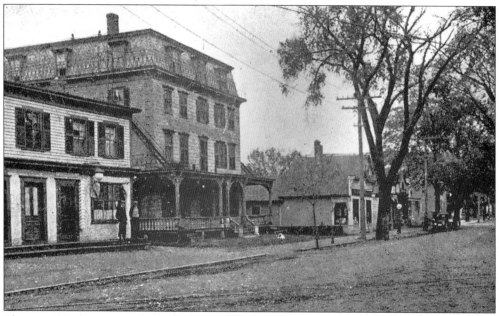

This *c*. 1900 photograph shows the Central House on Front Street and some of the adjoining stores. The building on the left housed a hardware business and served as post office for some time.

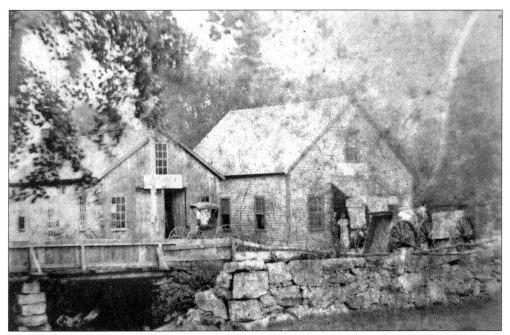

Many of Ashland's businesses were individually owned or family-owned operations. This was Piper's blacksmith shop on Concord Street, adjacent to the Sudbury River.

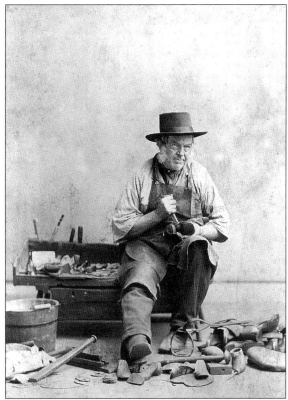

The boot and shoe industry was prominent from the mid-to-late 1800s. Prior to the Civil War, much work was done in homes or small boot shops. Nathan B. Ellis (Grandpa Ellis) plies his trade in such a shop. He went to the Centennial Exposition in Philadelphia to demonstrate his craft as part of the Tilton Boot and Shoe Company exhibit.

This photograph is titled "The Tin Pedlar." Francis H. Chickering was a well-known Ashland man who traveled the area towns selling household utensils, often bartering for rags in exchange. Here, his cart is on Beaver Street in Framingham, just south of Dennison's Crossing.

John Aldis Holbrook ran an ice and coal business for 34 years until 1926. He served as a selectman from 1901 to 1904 and again in 1906. He was one of five brothers in a family with roots in Ashland since 1860.

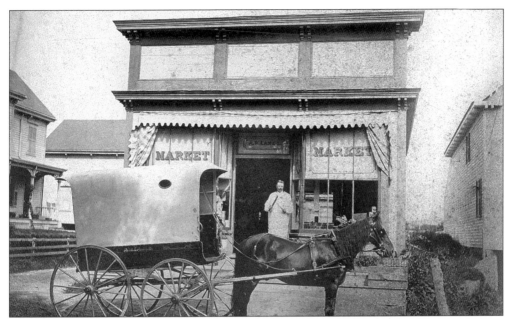

Albert W. Eames (1848–1912) poses in front of his market on the north side of Summer Street. Eames was the descendant of an early Ashland family and served the town in offices as selectman, assessor, and treasurer. At other times, he worked as paymaster for the Milford Pink Granite Company and at the Dennison Manufacturing Company.

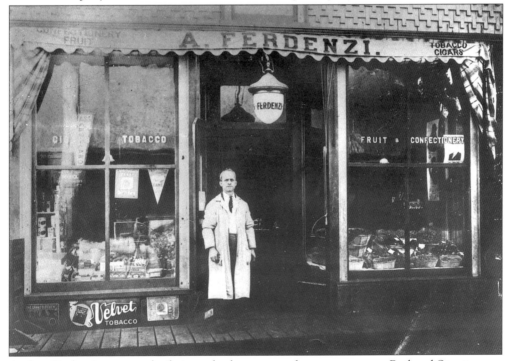

Andrea Ferdenzi ran a candy, fruit, and tobacco store for many years on Railroad Street across from the Ashland station. Born and married in Italy, Ferdenzi brought his family that eventually numbered three daughters and three sons to Ashland in 1911.

Lowell's Market was another of the small, family-operated businesses in Ashland. It was located on Railroad Street, next to Ferdenzi's. The store was on the building's ground floor with offices and a rooming house above.

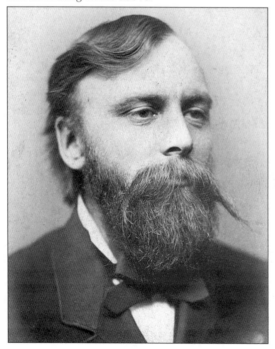

The town's druggist in the late 1800s was Fred Norman Oxley. His shop was located in the Odd Fellows building at the corner of Summer and Main Streets. He raised a family of five children in Ashland.

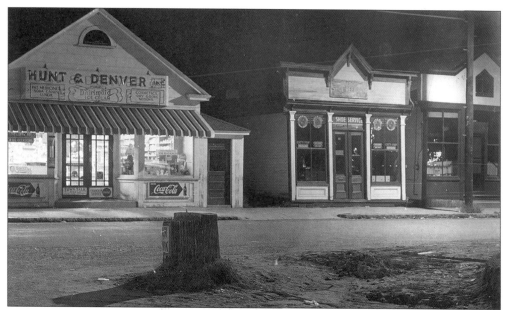

Stores on Front Street were Hunt & Denver's drugstore, a shoe repair shop, and a barbershop. The drugstore had been Whittemore's and the barbershop had been Stone's meat market. Alice Stone was the butcher and Ashland's first woman to serve on the board of selectmen.

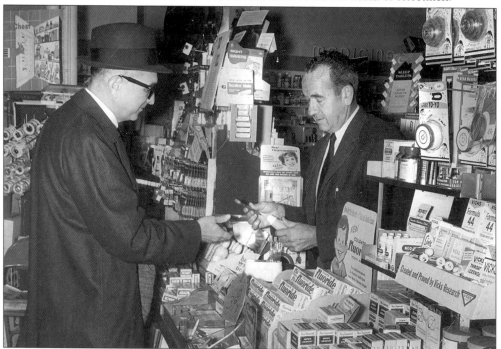

Eber Levine was the druggist in the mid-1900s. His store, Eber's Pharmacy, was on the southeast corner of Main Street and Homer Avenue from 1940 until 1976. His lunch counter was a favorite local hangout. "Mr. Eber" ran a customer-friendly store. He knew each and every person who came through the door. He had branch store in Framingham and South Natick also. He retired in 1975 and died in 1998.

This was John E. Woods in 1890. He came to Ashland in 1883 and, in partnership with Henry Pike, opened a grocery business on the first floor of Abner Greenwood's building at Front and Concord Streets. When the partnership broke up, Woods kept the business, known as Boston Branch, going for many years.

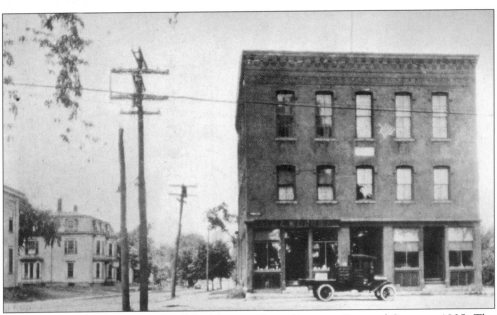

This was Abner Greenwood's brick building on Front Street at Concord Street c. 1905. The third floor was occupied by the Masons. John E. Wood's Boston Branch store was on the first floor to the left.

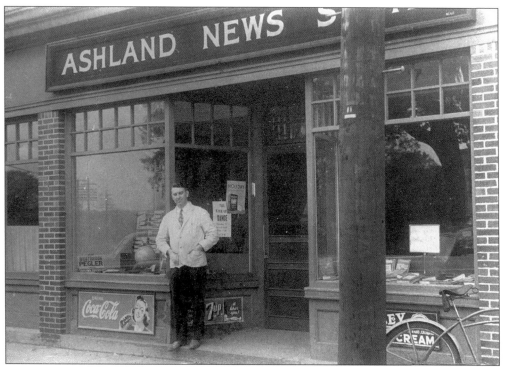

The proprietor of the Ashland News Store on Main Street for many years was Arnold Bean. The store was the exclusive distributor of newspapers in town. This photograph dates from c. 1944. (Courtesy of Robert Hebden.)

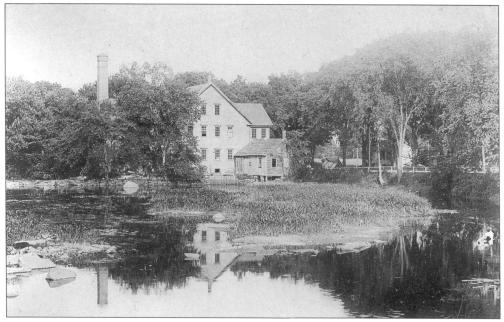

Metcalf's Box Mill on Pleasant Street is seen across the millpond in a photograph taken from the Fisher Street bridge. A mill occupied this site as early as 1847. This one was built by Abrah Metcalf in 1878. Fire destroyed it in 1932.

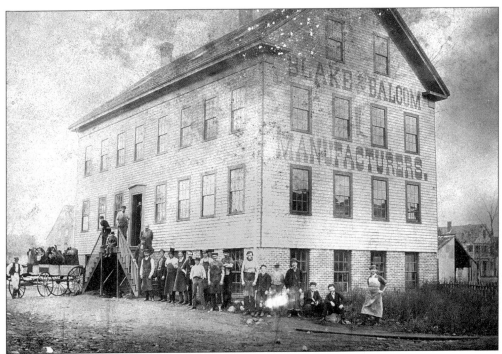

This was the Blake and Balcom shoe factory *c.* 1863. It was built on the south side of Front Street, opposite where the Masonic building and the public library are today.

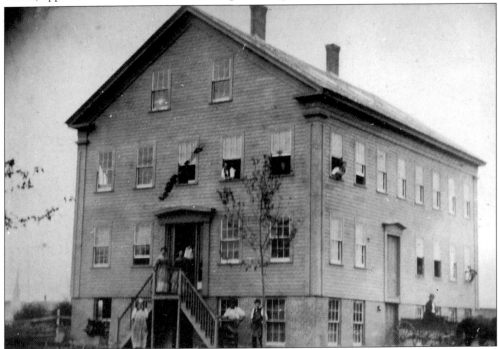

Charles H. Tilton opened his first boot shop in this building on Pleasant Street in 1850. Several wings were added over the years to enlarge the facility considerably. It became recognized as a model boot and shoe factory.

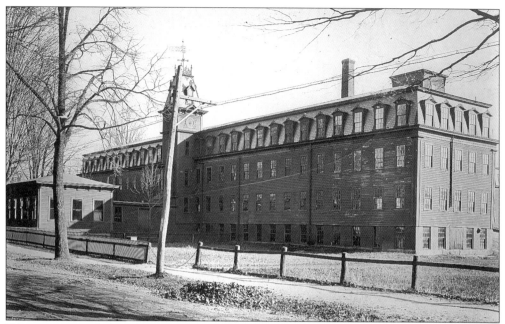

Tilton's Boot and Shoe flourished. This large factory on Pleasant Street was 185 feet long and four stories high. A storehouse and subsequent additions extended the back of the building all the way to the railroad tracks. Tilton retired in 1886, selling the business to Houghton, Coolidge & Company.

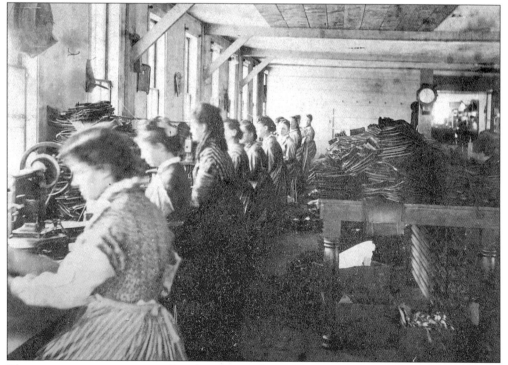

These young women were employed in the stitching room at Tilton's Boot and Shoe factory. Tilton's was the first boot manufacturer in Ashland.

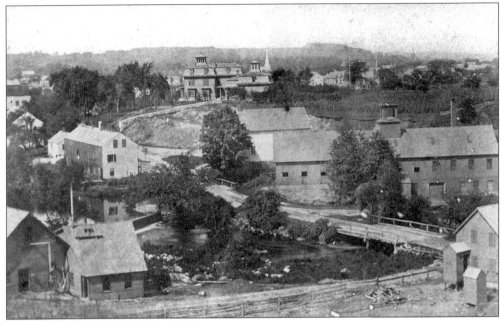

Charles Alden purchased the Shepard paper mill property at Fountain and Union Streets in 1855. He engaged in the production of emery powders here. The business was incorporated as Washington Mills Emery Manufacturing Company in 1868. The mill operated until 1878, when it was destroyed by fire. On the hill beyond the mill is the Bigelow estate.

Charles Alden came to Ashland c. 1855. He owned a monopoly on emery manufacture from imported Smyrna stone. He operated the business until 1878 as Alden Emery, Washington Mills, and Vitrified Wheel and Emery Company. Alden was active in town affairs and was an extensive home builder.

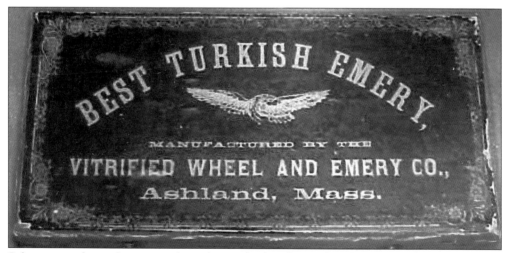

This 1878 invoice is for half kegs of various grades of emery powder from Washington Mills. The customer appears to be Gillete & Company. Emery powder was a widely used abrasive at the time. The company Charles Alden started is in business today with headquarters in Grafton, Massachusetts, and still produces abrasive materials

Salesmen used sample cases such as this to display the grades of emery produced by Alden's Vitrified Wheel and Emery Company. (Courtesy of Clifford Wilson.)

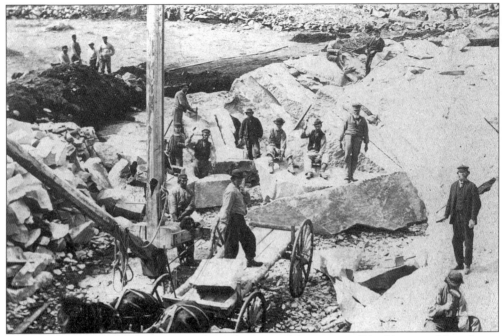

The Dwight Printing Company started construction of the stone mill buildings on Main Street in 1869. The granite came from this local quarry, which was located on a 24-acre site between Winter and Myrtle Streets.

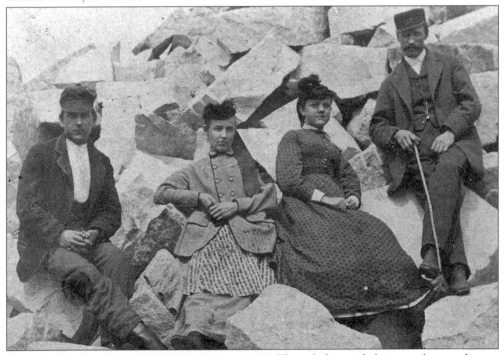

The granite quarry was a local attraction in 1869. These ladies and their gentlemen chose a good vantage point to observe the work in progress or, perhaps on a Sunday outing, to enjoy the view of the countryside from their perch.

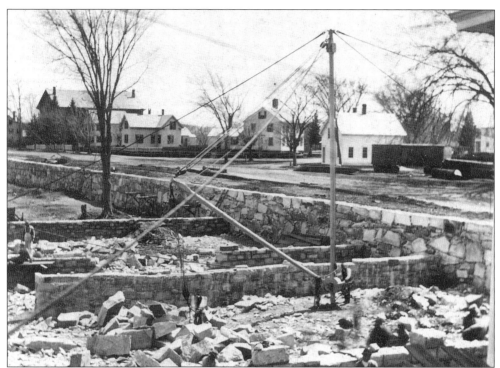

These stoneworkers are putting up the foundation walls for the Dwight Printing Company mills on Main Street. The Ashland Town Hall can be seen in the distance. The mills were never finished completely because the Boston Water Board usurped water rights to the Sudbury River in 1872.

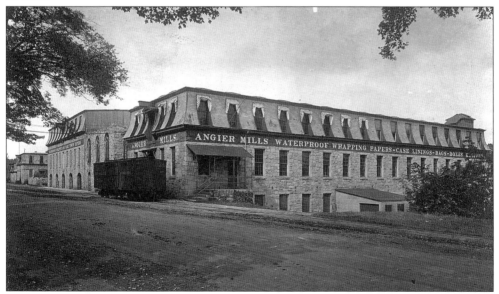

The mill complex was largely unoccupied for a number of years. Eventually, some small manufacturing businesses arrived. Angier Mills occupied some of the Main Street mill buildings in 1911. They produced canvas-reinforced, waterproof wrapping papers here until fire destroyed the plant in 1922.

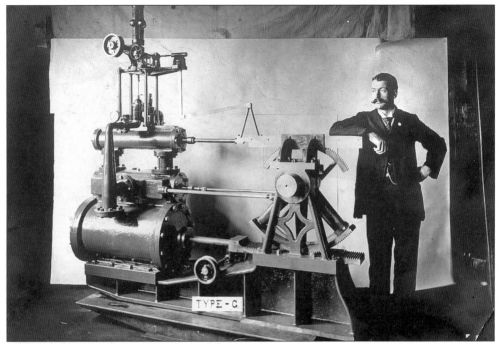

Nathaniel Lombard, in 1844, invented a way of regulating the speed of waterwheels and turbines. His company, Lombard Governor Company, moved into the Main Street mills in 1904. The superintendent of the Lombard plant was young Henry E. Warren.

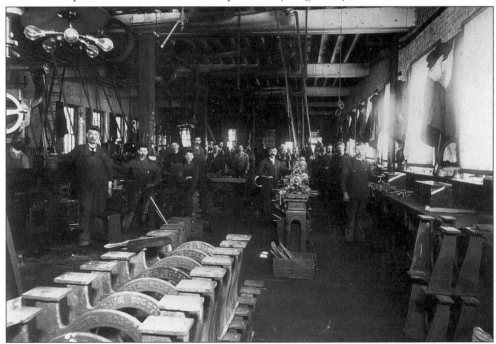

The Lombard Governor Company made good use of the waterpower to run its machinery. This c. 1905 view of the interior of the plant shows a myriad of transmission belts running lathes and other equipment.

Henry Ellis Warren was an 1894 graduate of the Massachusetts Institute of Technology. He became superintendent of the Lombard Governor Company in 1902. Soon after moving to Ashland, he began experimenting with gears and motors in the barn behind his home. It was here that he invented the synchronous motors and master clocks that made accurate electrical timekeeping possible. He had more than 135 patents issued to him. In 1912, he founded the Warren Clock Company, eventually Telechron. In 1937, he bought Lombard Governor. Further contributing to the economic recovery in Ashland, Warren helped found the Fenwal Corporation. He was very active in town affairs, even serving as a selectman.

Henry E. Warren married Edith B. Smith in 1907. She was a 1902 Radcliffe graduate and was employed as a schoolteacher. The couple moved into a farmhouse on Chestnut Street, and it remained their home until 1957.

This was the Warren Clock Company office in the company's earliest years. It had been the home of Charles Alden. It was located on Homer Avenue, opposite the east end of Central Street.

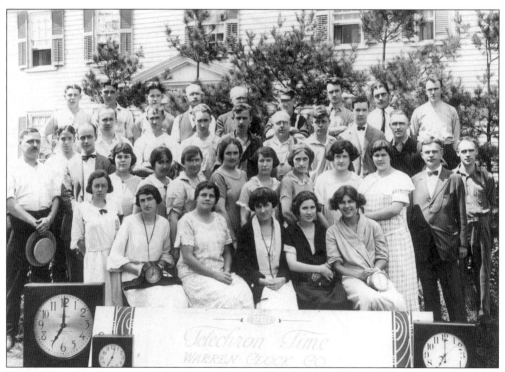

Henry Warren held an outing for the employees of his fledgling Warren Clock Company at his farm on Chestnut Street. Some of the earliest clocks they manufactured are displayed in this c. 1916 photograph. (Courtesy of Robert Hebden.)

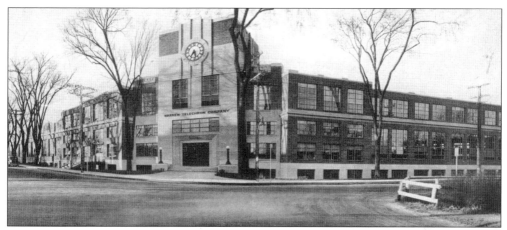

In 1927, Warren moved his growing business (now the Warren Telechron Company) into new quarters on the northeast corner of Homer Avenue and Union Street. With subsequent additions, the plant soon looked as it appears in this photograph.

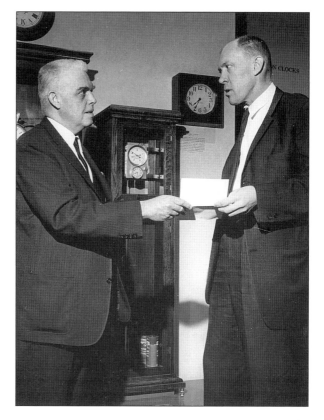

It was necessary to control closely the frequency of the electrical power being generated by power plants in order for electric clocks to keep accurate time. Henry Warren invented the master clock and convinced Edison Electric to install it in its South Boston plant. It soon became an industry standard. This photograph was taken at the time that the original master clock was presented to the Smithsonian Institution in Washington and placed on display, where it may be seen today.

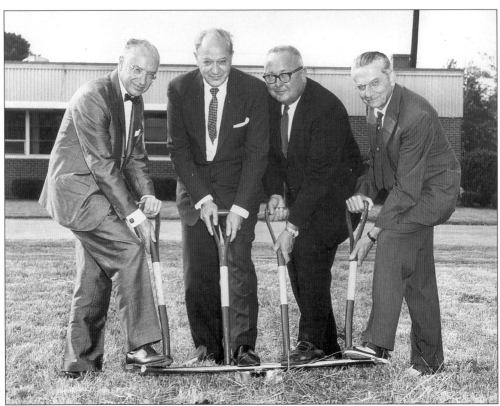

Fred J. Turenne (far right) invented a thermal switch to regulate the temperature in appliances. In association with Dr. Carl W. Walter (second from left), he started Fenwal. Here, with Ed Poitres (far left) and Jack Stockerson, they take part in a groundbreaking ceremony outside the company's research and development center.

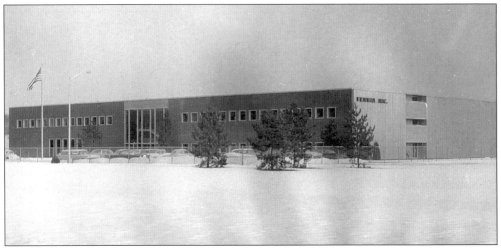

Fenwal moved to Ashland in 1938. In 1943, they occupied the old C.H. Tilton shoe factory on Pleasant Street. It was 1962 when they made the move to the facilities off South Main Street.

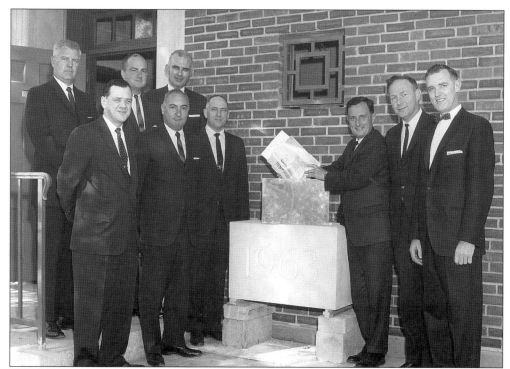

Ashland's growth merited its own New England Telephone building in 1963. Selectmen George Tegelar, Arnold Baker, and Colby Scott joined representatives of the company and contractors for the cornerstone laying at the Main and Union Streets facility.

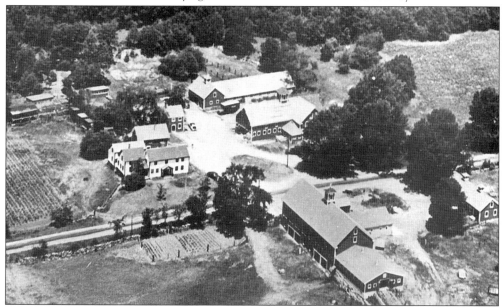

Whitney Farm was a large beef and dairy operation on Eliot Street, north of Pond Street. This 1960 photograph shows the array of buildings along Eliot Street. Owned by the Katsoff family, the farmhouse was the oldest dwelling (c. 1737) in Ashland at the time. Spectacular fires destroyed the structure.

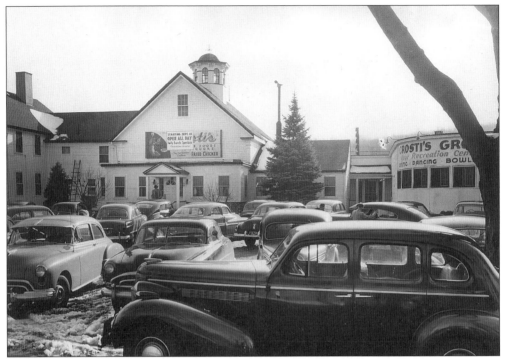

Crosti's Grove became a very popular recreation attraction during World War II. It was a short ride to find entertainment for many servicemen and women from the Cushing military hospital in Framingham. The restaurant on Pleasant Street occupied an old house and attached barn. A bowling alley with eight lanes was added. In later years, the band Aerosmith was often featured in the lounge. This photograph was taken in 1952.

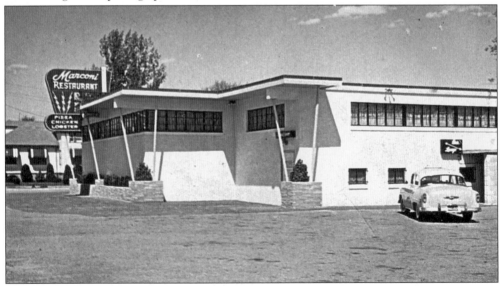

Another Ashland landmark was Marconi's Restaurant. It opened on Pond Street in 1937 and was a favorite of people for many miles around. Mention Ashland to someone from out of town and a pretty sure bet was that they would tell you they knew of Marconi's. It closed only recently.

Seven

TRANSPORTATION AND THE BOSTON MARATHON

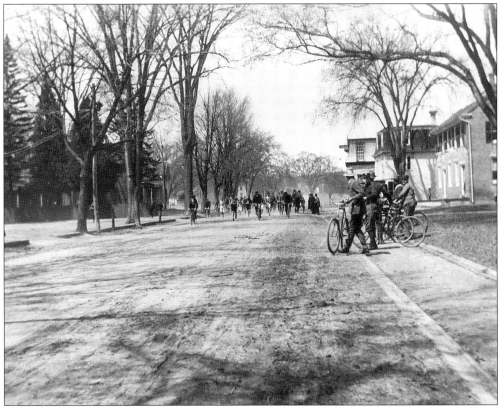

Seen here are the 1899 Boston Marathon runners after turning the corner from Pleasant Street onto Main Street. Seventeen men started in front of Metcalf's Box Mill on Pleasant Street. The winner reached Boston in 2 hours and 55 minutes.

Until well into the 20th century, many of Ashland's roads were no more than cart paths connecting the village with outlying farms. This view of Howe Street is typical.

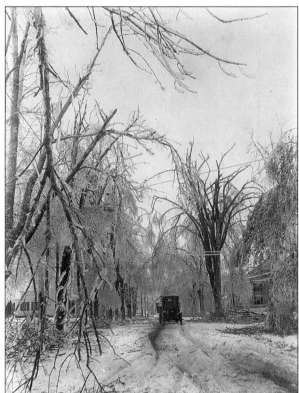

Often times, even the better roads in town were difficult to navigate. This Model T truck is making its way along Summer Street in 1921 after a particularly bad ice storm.

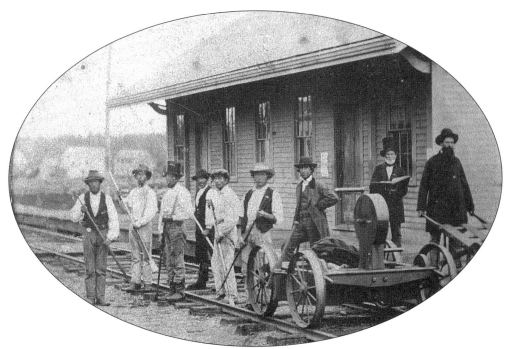

This was Ashland's first railroad depot *c.* 1860. James H. Jones, ticket agent from 1841 to 1873, is in the top hat on the platform. Wheeling a baggage cart on the right is the baggagemaster, Silas Piper.

The railroad gatehouse on the east side of the Main Street crossing is shown in the late 1800s. The structure provided shelter for the man who operated the crossing gates manually.

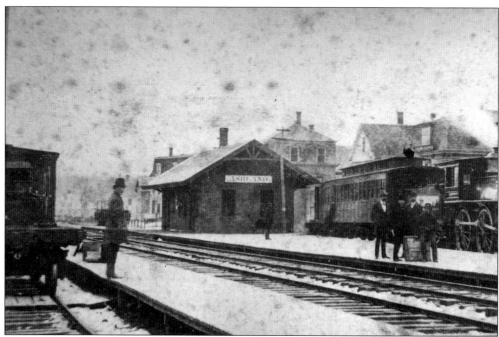

This is a view of Ashland's busy depot. The second track on the main line of the Boston & Albany Railroad was laid in 1868. The train to the right is on the Hopkinton Railroad spur that was completed in 1872, providing service to Milford. The station was damaged by a wayward freight car loaded with lumber on that spur track.

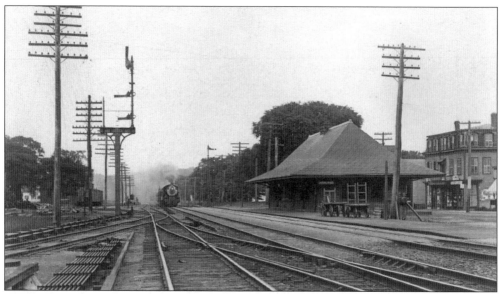

Ashland's new station was built in 1888 and is shown here with a westbound train approaching. Each steam engine had a distinctive whistle readily recognized by residents.

This *c.* 1920 view from Front Street shows the Main Street crossing with the Odd Fellows building and the Ashland Hotel in the background. Note that the top of the Odd Fellows building had burned and been replaced with a flat roof.

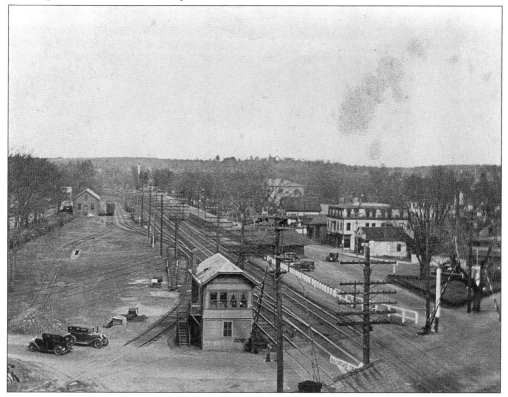

This view of downtown was taken from the tower in the new fire station *c.* 1930. In addition to the two main tracks, there are spurs serving the old factory on Pleasant Street, the stone mills on Main Street, and the warehouse on Front Street.

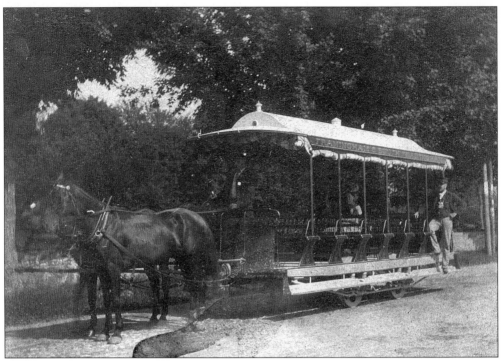

Horse-drawn trolleys connected the town with Framingham and Hopkinton during the late 1800s. The line was electrified at some point in time using the same trolley rails.

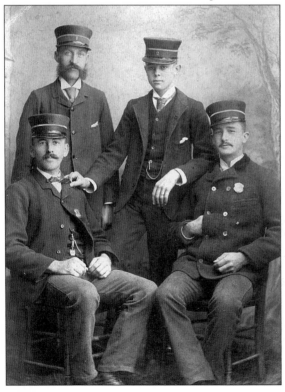

Four of the horsecar operators are shown here. They are, from left to right, Fred Johnson, Dick Neary, E. Emerson, and George York.

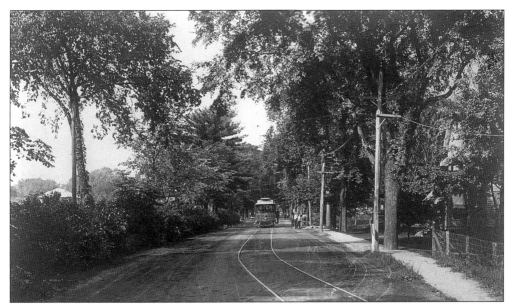

Here is one of the South Middlesex Street Railway Company trolleys on Summer Street. Stone Park is to the left. These cars operated from 1893 to 1920, providing service between Natick and Hopkinton through Sherborn, Framingham, and Ashland.

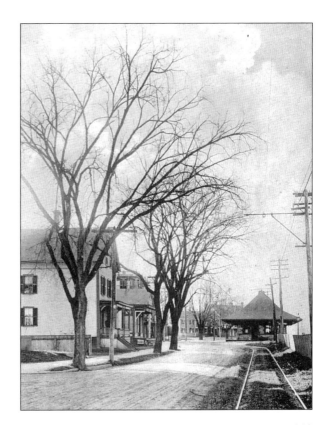

This *c.* 1910 view shows the electric trolley track along Railroad Street (now Homer Avenue). The Ashland station is visible.

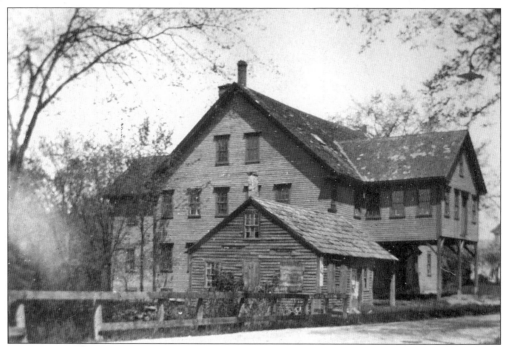

The original Boston Marathon course was based upon the railroad. Officials followed the line west to a point 25 miles from Boston. The starting line for the 1897 to 1899 races was on Pleasant Street in front of Metcalf's Box Mill.

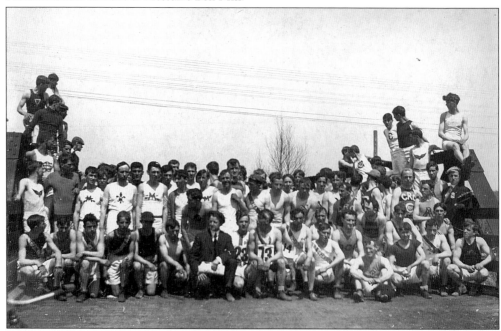

In 1900, the starting line was moved two-tenths of a mile west to the High Street bridge over the railroad tracks. This photograph of the starting field was taken in 1906. A year later, the bridge was under repair and the starting point was moved to Steven's Corner (West Union and Olive Streets) until 1924.

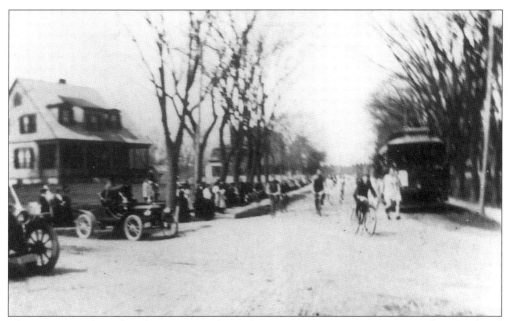

This was marathoning! The runners, shown here turning onto Union Street from Railroad Street, were attended by friends on bicycles. Spectators followed the progress of the race from trolley cars.

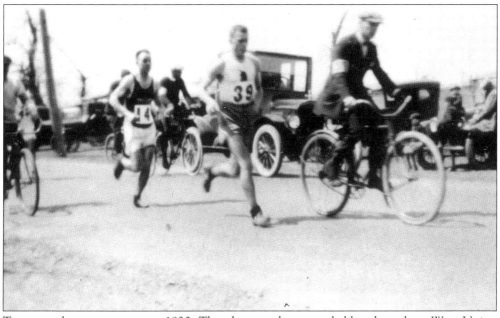

Two marathoners compete c. 1920. The photograph was probably taken along West Union Street. The race started at Steven's Corner on West Union Street in Ashland from 1907 to 1923.

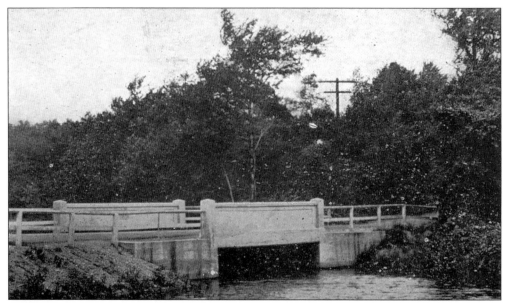

Bridges spanning the Sudbury River were important in providing access between various parts of town. This is the Fisher Street bridge, built in 1921 reportedly as an early project of the Perini Corporation. It carried the road from the western end of Pleasant Street to Winter Street. Today, we know it as Cordaville Road.

These two bridges were built in 1924 to carry Myrtle Street across the Sudbury River, just below the millpond dam.

Eight
THEY SERVED
THEIR COUNTRY

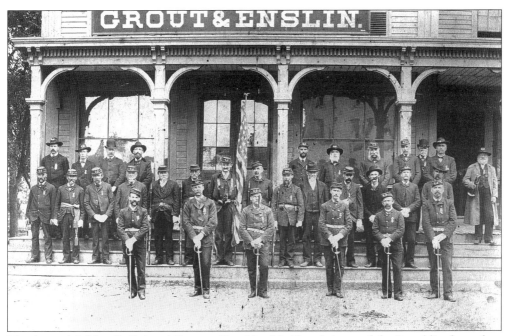

Members of Ashland's Colonel Prescott Post No. 18, Grand Army of the Republic, formed up in front of the GAR building. The hall was on the upper floor of the building at Main and Summer Streets, where today's post office stands. This photograph is dated *c.* 1890.

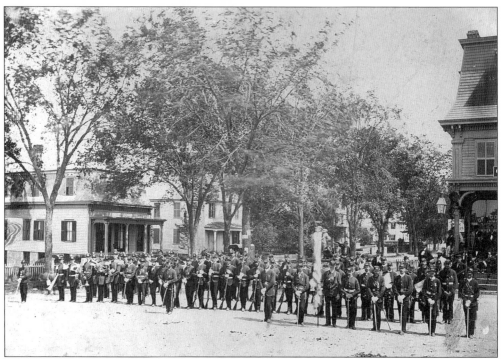

The Colonel Prescott Post No. 18 of the Grand Army of the Republic is in formation at the intersection of Main and Summer Streets in preparation for a Memorial Day parade *c.* 1875. Ashland supplied 184 men to the Union Civil War forces.

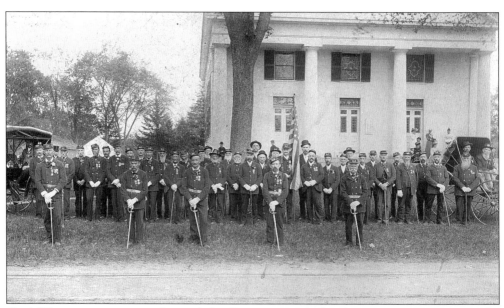

Civil War veterans pose in front of the Congregational church on Main Street. Note the carriages provided for those GAR members no longer up to the march in the annual Memorial Day parade.

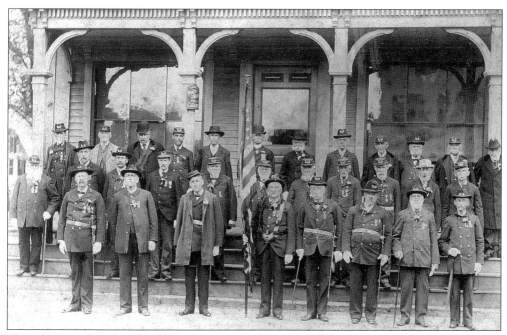

This photograph is dated *c.* 1910. At its peak, the Ashland GAR post could muster over 250 men who served in the Union army and navy during the Civil War.

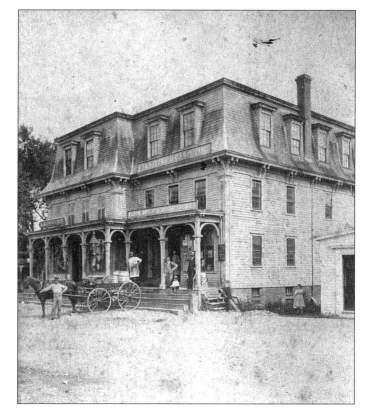

This *c.* 1890 photograph shows the GAR building. The GAR did not own the structure but met there in the third-floor meeting hall for more than 50 years. In 1931, the building was lost to fire. By that time, the GAR post was no longer a viable organization and was supplanted by the American Legion and Veterans of Foreign Wars.

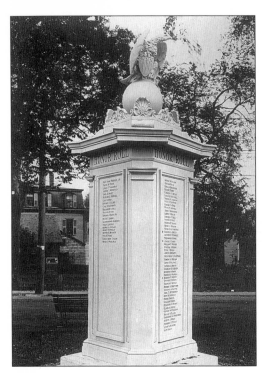

This wooden monument was erected by the town in honor of the men from Ashland who served in the armed forces during World War I. It stood in the center of town at Richard T. Murphy Square (see page 76).

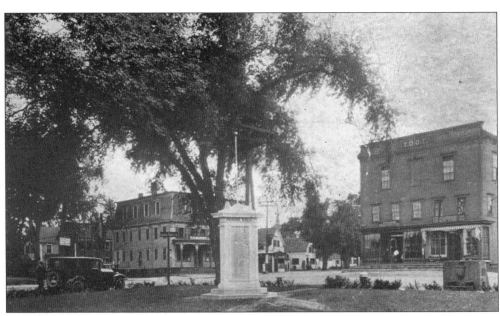

The World War I honor roll is seen *c.* 1925. The GAR building is on the far corner, and the Odd Fellows building is to the right. Both buildings were destroyed by fires in 1931 and 1943. Ashland sent 112 men and two women off to World War I. Seven were lost.

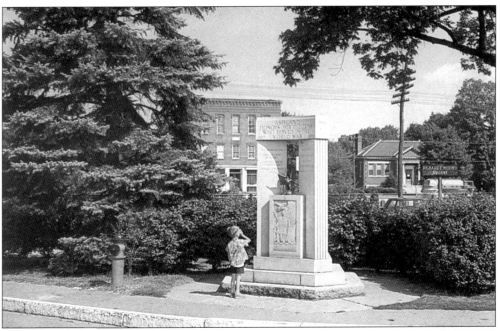

This is Richard T. Murphy Square with a more permanent World War I honor roll featured. The Masonic building and the public library on Front Street are visible in the background.

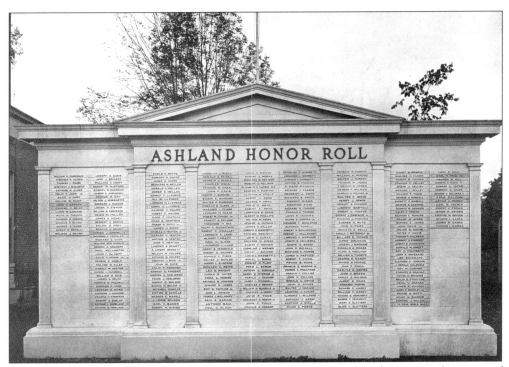

This honor roll was erected by the American Legion to remember the men and women of Ashland in the armed services during World War II. It was located on Summer Street beside the new post office. This photograph was taken in 1943. Six local men lost their lives in that war.

For many years, Ashland's veterans' organizations occupied old buildings in town. The Veterans of Foreign Wars occupied a building on Pleasant Street and the American Legion occupied this one on Summer Street. This was the former Baptist church.

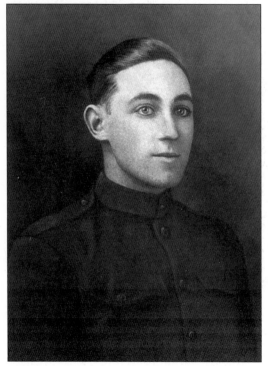

Ashland's American Legion Post No. 77 is named for James O'Neil Carey. This 21-year-old son of John Carey and Mary Keady Carey was the first Ashland man killed in World War I. A private first class in Company C, 102nd Infantry, he died in April 1918 at Seicheprey, France, and was buried in the American cemetery at St. Mihiel. He left a new wife and infant child.